CENTRAL MANCHESTER

THROUGH TIME

Jean & John Bradburn

AMBERLEY

D1350447

First published 2016

Amberley Publishing
The Hill, Stroud
Gloucestershire, GL5 4EP

www.amberley-books.com

Copyright © Jean & John Bradburn, 2016

The right of Jean & John Bradburn
to be identified as the Author of this work
has been asserted in accordance with the
Copyrights, Designs and Patents Act 1988.

ISBN 978 1 4456 4953 5 (print)
ISBN 978 1 4456 4954 2 (ebook)

British Library Cataloguing in Publication Data.
A catalogue record for this book is available from
the British Library.

Typesetting by Amberley Publishing.
Printed in the UK.

Introduction

In AD 79 the Romans arrived in Manchester (Mancunium). The fort was sited to defend the route between Chester and York. They chose a site on the top of a small hill, looking down on the confluence of the rivers Medlock and Irwell. Who could have imagined when the Romans built their fort in this cold, damp region of North West England what a great city they had founded? This damp air, ideal for spinning cotton, accounted for Manchester's future wealth. To put things in to perspective, as Manchester was emerging, the city of Pompeii was being destroyed.

After the Norman Conquest in 1066 the barony of Manchester came into the possession of Albert Grelley.

From 1223 a fair was held on Acres Field (St Ann's Square).

Manchester proved to be radical at a very early stage. In 1301 the Great Charter of Manchester gave rights to women. They could now trade in their own right and be members of a guild, privileges, denied to women elsewhere. There were no restrictions on who could trade and here we see the early signs of Manchester's free trade tradition.

The medieval town grew up close to the current site of Manchester Cathedral. At this time Manchester was in the Salford Hundred, but there has been a parish church on or near the site of the cathedral since the late Anglo-Saxon or early Norman period. In 1421 the parish church was raised to the status of a collegiate church (a church served by resident canons). It was elevated to cathedral status in 1847 and dedicated to St Mary, St Denys and St George.

Manchester had a textile tradition even in medieval times. Flemish weavers had settled in Manchester in the fourteenth century and brought their crafts with them. By 1800 fifty steam-powered cotton mills dominated the town. 'Cottonopolis' was taking shape!

When civil war came to America in 1861, the supply of cotton to Lancashire was blockaded. Despite these hardships the workers supported Abraham Lincoln's anti-slavery policy, resulting in great suffering for the Manchester-based cotton workers. This was an extraordinary gesture and would prove to be costly to the mill workers as many of them faced starvation and destitution.

An industrial town needs good transport links and Manchester made sure that the town achieved them.

First, Lord Bridgewater built his canal to move coal and later cotton for export. Then, in 1830, the Liverpool and Manchester Railway began to challenge the canals as a means of transport.

The construction of the Manchester Ship Canal gave the city direct access to the sea, allowing it to export its manufactured goods directly

without the reliance on Liverpool's ports. When completed in 1894 it allowed Manchester to take its place as Britain's third busiest port, despite being 40 miles inland.

Manchester's wealth came with a price. At that time, men, women and children worked the mills. The hours were long and the work was hard and dangerous. Poor quality houses were built to provide for the increasing population. These were crowded, squalid and encouraged disease. Not surprisingly a cholera epidemic hit Manchester in 1832. Manchester's slums became notorious. When Frederick Engels arrived in Manchester to work at his family's firm he was horrified at the conditions of the working men and women. This resulted in his famous book *The Condition of the Working Class in England* published in 1845. He also met and became a lifelong friend of Karl Marx and together they published *The Communist Manifesto* in 1848.

Throughout its history the city has not been short of men and women who were devoted to social and educational reforms. John Bright, John Dalton, Richard Cobden, the Quakers, the Methodists and the Unitarians all worked to improve the lot of the working classes. Manchester was to become the centre of the cooperative movement.

The people of Manchester have always a provided a powerful voice for political reform; from the Peterloo Massacre to the Great Reform Act and the repeal of the Corn Laws, to the Suffragette movement. John Cobden and John Bright were the acknowledged leaders of what came to be known as the Manchester School, which espoused free trade and an economic system free of government interference.

The Manchester Literary and Philosophical Society was established in 1781, Its past members have included Roget, Dalton, Joule, Fairbairn, Kilburn and Rutherford; it is the first and oldest literary and philosophical society in the world and is still going strong in the city today.

Manchester has a strong tradition in music and arts as well as radical politics. Britain's oldest professional orchestra was founded in Manchester by Charles Hallé and music has been a major part of city life ever since.

Manchester can be justly proud of its history through the ages.

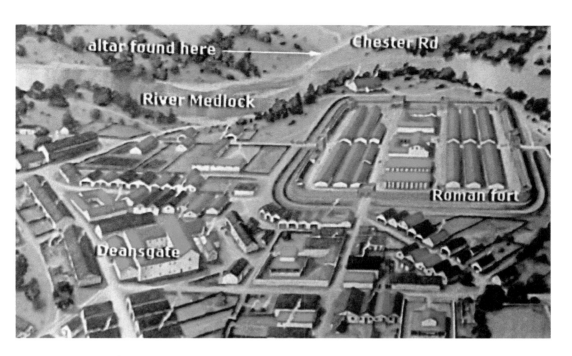

Roman Manchester, AD 79

The Roman fort of Mancunium was the birthplace of modern Manchester. This artist's impression by Graham Sumner gives us an idea of what it may have looked like. It was a timber fort with earthen ramparts for an infantry of around 500 men. We now know there was a Roman temple behind what is now the White Lion on Liverpool road, an hotel on Deansgate opposite the Hilton Hotel, and Roman buildings on the east side of Deansgate on the actual site of the Hilton Hotel. Castlefield has now been turned into a heritage park with notice boards explaining the historic importance of the area.

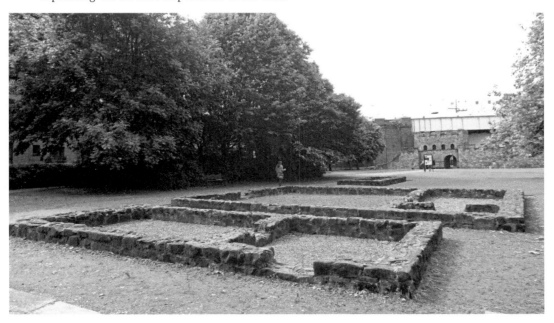

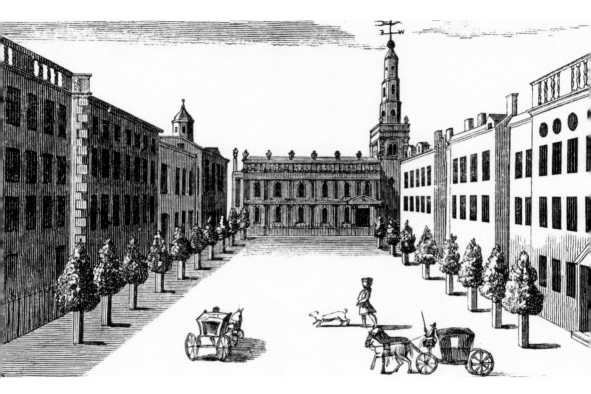

St Ann's Square, 1741

A fine view of the Georgian square. Originally called Acres Field, a fair was held here since the days of Henry III in 1227. In 1709, Lady Ann Bland laid the foundation stone of St Ann's church, that was consecrated by Bishop of Chester in 1712. John Wesley preached here in 1738. During the Jacobite rebellion, Charles Edward Stuart, the Young Pretender, rode into the square and reviewed his troops. The square became the most fashionable shopping district in Manchester. We see the square marked 'E' on an early plan of the town.

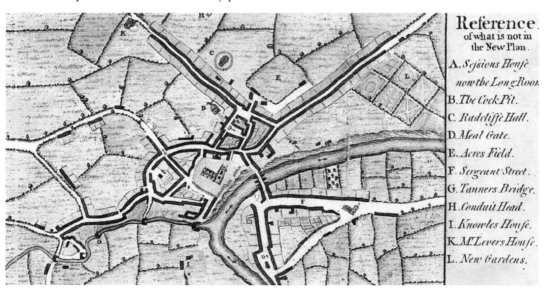

Reference.
of what is not in
the New Plan.

A. *Seßions Houße*
 now the Long Room.
B. *The Cock Pit.*
C. *Radcliffe Hall.*
D. *Meal Gate.*
E. *Acres Field.*
F. *Sergeant Street.*
G. *Tanners Bridge.*
H. *Conduit Head.*
I. *Knowles Houße.*
K. *Mr Levers Houße.*
L. *New Gardens.*

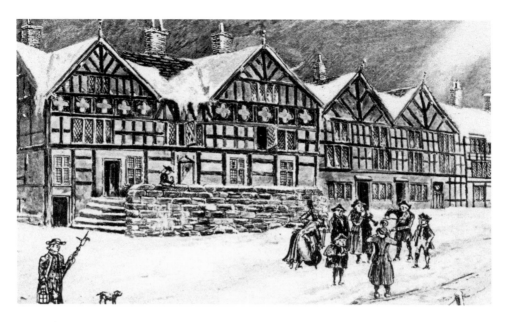

Byrom's House, Cateaton Street, 1750

John Byrom, the Jacobite poet and author of the famous hymn 'Christians Awake' lived here. The image above shows the house in the snow on Christmas Eve in 1750. The hymn was written as a Christmas present for his daughter Dolly – a wonderful hymn to be sung on Christmas morning. Although he was known as a Jacobite, he was lukewarm towards Charles Edward Stuart on his entry into Manchester in 1745. His daughter Elizabeth went to kiss the Young Pretender's hand, and reported that her father was reluctant to do so. This part of town has since been transformed into a modern shopping centre.

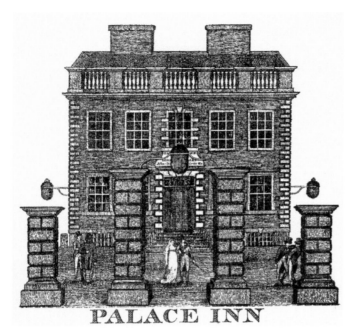

PALACE INN

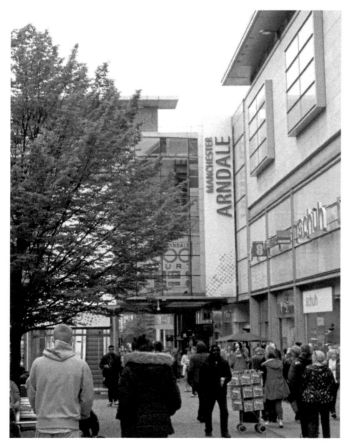

Palace Inn, Market Street Lane, 1820

The house was on the north side of what is now Market Street. In 1745, Charles Edward Stuart attempted to regain the British throne for the exiled House of Stuart. When Bonnie Prince Charlie arrived in Manchester he lodged at Mr Dickenson's house in Market Street Lane and it became known afterwards as the 'Palace'. Some 300 recruits had joined the invaders, and were called the Manchester Regiment. The house later became an inn and here we see it in 1820. How very different from the Arndale Centre we see today.

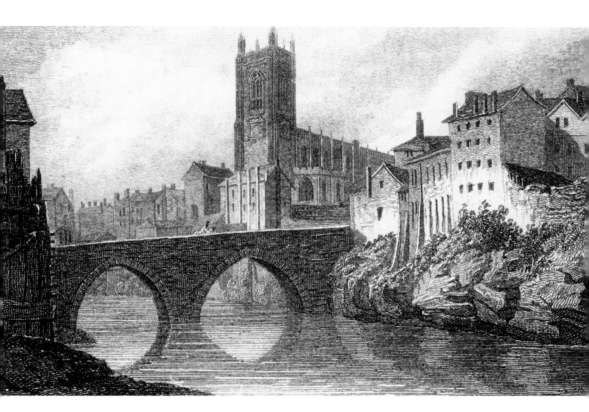

Salford Old Bridge, 1800
This was the first stone bridge to be built across the River Irwell. It was replaced by a sandstone bridge in 1839. In 1800 the cathedral was still known as the collegiate church. It is dedicated to St Mary, St Denys and St George. It was built in 1421. The collegiate church of Manchester was the parish church for a huge area and was the only choice for the poor of Manchester. So for financial reasons many couples were married at the same time.

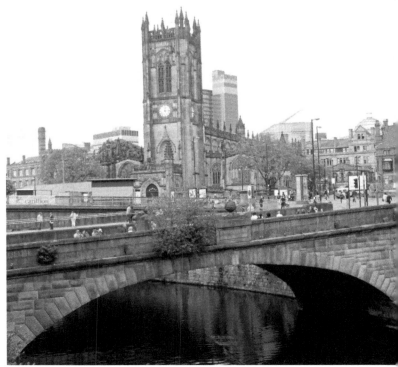

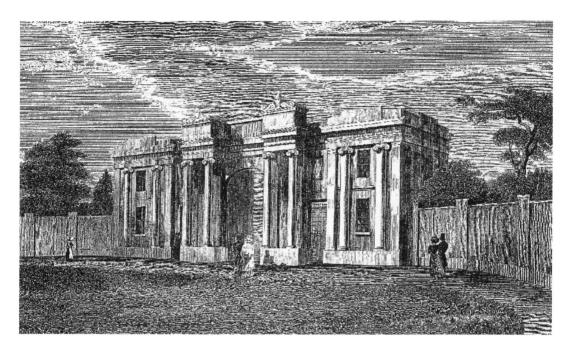

Botanical Gardens, 1827

This was the site of Manchester Botanic Gardens in Old Trafford. The purpose was to lay out gardens for the recreation of the citizens of Manchester, who would otherwise be deprived of such pleasures in the industrial city. In 1857 the gardens hosted the spectacular United Kingdom Art Treasures' Exhibition, which was opened by Prince Albert. The exhibition attracted in excess of 1.3 million visitors over a period of 142 days. The botanic gardens closed in 1907. The site was leased to the White City Ltd. It became an amusement park and sports stadium. The fine entrance still stands today, in front of White City Retail Park.

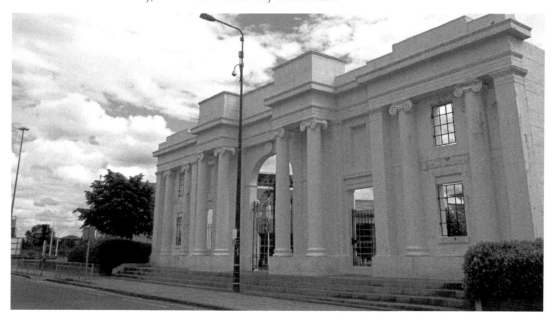

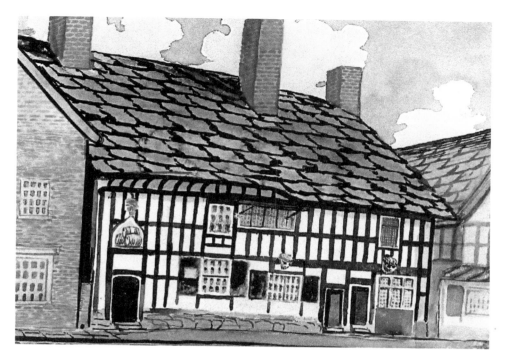

Three Tuns Alehouse, Fennel Street, 1820

This area was once known as Apple Market; it was the site of the fruit markets which were held here near the cathedral from 1769 onwards. Baines's Directory of 1820 shows this inn and a pub named The Apple Tree. This style of black and white houses was typical of early Manchester. This was also the site of an old city graveyard. We now see the landscaping and football museum.

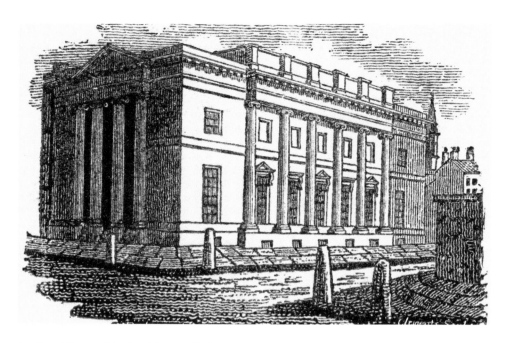

Portico Library, Mosley Street, 1806

Built in Greek revival style it was established as a result of a meeting of Manchester businessmen in 1802 which resolved to found an 'institute uniting the advantages of a newsroom and a library'. The Athenaeum in Liverpool inspired them to achieve a similar institution in Manchester. Money was raised through members' subscriptions and the library opened in 1806. Today, the building accommodates an exhibition space and the ground floor is tenanted by The Bank public house which takes its name from the Bank of Athens which leased the property in 1921. The subscription library remains upstairs with its entrance on Charlotte Street.

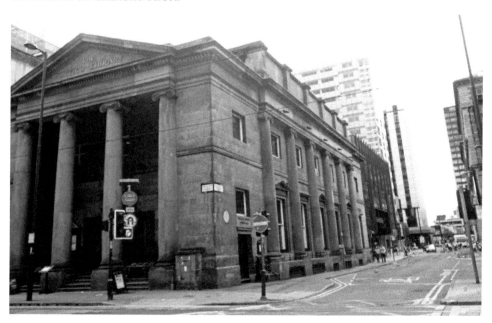

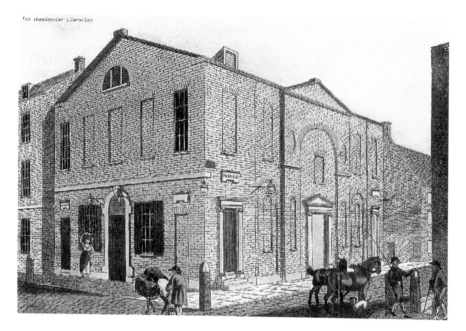

Theatre Royal, York Street, 1803

The image above shows the first Theatre Royal, which opened in 1775 at the junction of Spring Gardens and York Street. It burned down in 1779. The Queen's Theatre was built on the same site later. The fine building we now see on the corner is the superb former Parr's Bank of 1902. Designed by Charles Heathcote, it is bold Edwardian baroque-style with art nouveau motifs in the iron work. The interior is one of the most opulent of this date still standing in Manchester. It was later the Athenaeum, but is now Browns restaurant.

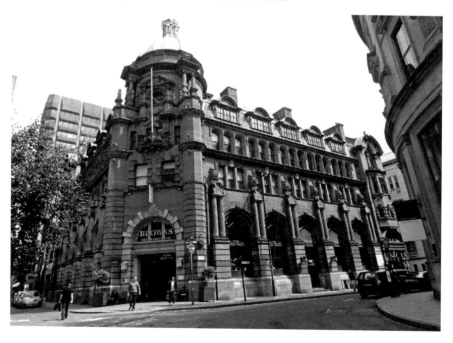

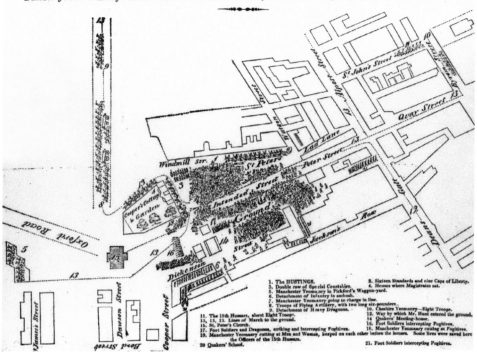

Map of St. Peter's Field, Manchester,
AS IT APPEARED ON THE 16TH OF AUGUST, LAST:
Taken from a Draft made under the Direction of Messrs. Pearson, Harmer, and Denison.

1. The HUSTINGS.
3. Double row of Special Constables.
5. Manchester Yeomanry in Pickford's Waggon-yard.
6. Detachment of Infantry in ambush.
7. Manchester Yeomanry going to charge in line.
8. Troops of Flying Artillery, with two long six-pounders.
9. Detachment of Heavy Dragoons.

2. Sixteen Standards and nine Caps of Liberty.
4. Houses where Magistrates sat.

11. The 15th Hussars, about Eight Troops.
13, 13, 13. Lines of March to the ground.
15. St. Peter's Church.
17. Foot Soldiers and Dragoons, striking and intercepting Fugitives.
19. Manchester Yeomanry cutting at Men and Women, heaped on each other before the houses. Some lives were saved here by the Officers of the 15th Hussars.
20 Quakers' School.

10. Cheshire Yeomanry—Eight Troops.
12. Way by which Mr. Hunt entered the ground.
14. Quakers' Meeting-house.
16. Foot Soldiers intercepting Fugitives.
18. Manchester Yeomanry cutting at Fugitives.

21. Foot Soldiers intercepting Fugitives.

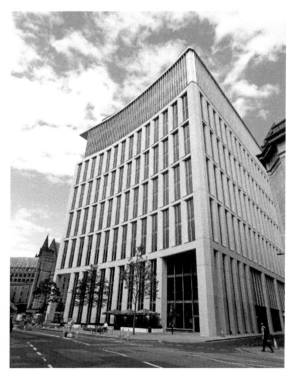

St Peter's Field, 1819

A plan of the site of the infamous Peterloo Massacre, showing the people and the position of the vast deployment of troops. The introduction of the Corn Law in 1804 restricted the importation of corn and brought about deep suffering to the working classes as bread became expensive. Trouble had been brewing for some years in Manchester. On the morning of 16 August 1819 crowds began to assemble from all over the area, often walking long distances. The square today is once more being altered and we see the new office block opposite the Central Library.

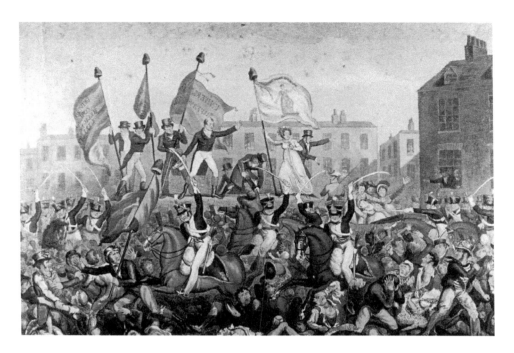

The Peterloo Massacre

The size of the crowd at St Peter's Field so alarmed the City Magistrates that troops were called in to disperse it, and turned what should have been a peaceful meeting to appeal for change, into a massacre when the yeomanry charged the gathering. Eleven people were reported killed and 140 injured in the resulting chaos. Moderate reformers in Manchester were appalled by the decisions of the magistrates and the behaviour of the soldiers. The name Peterloo, combines Manchester's traditional meeting place, St Peter's Fields, with the battle of Waterloo, which was fought four years earlier. The view of the cenotaph today is a fitting reminder of the loss of life near this square.

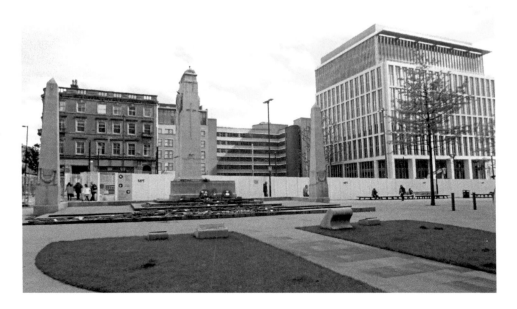

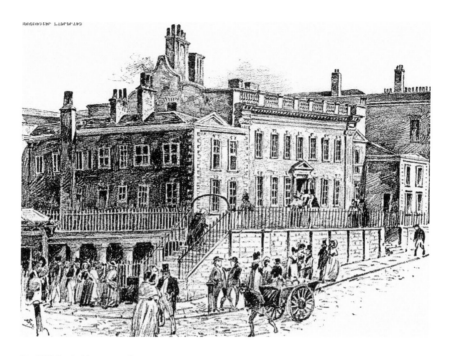

Dr White's House, 1820

This fine house, on the corner of Cheapside and King Street, was the home of Charles White, MRCS FRS. He operated a surgery from here. He was also the surgeon to the Manchester Royal Infirmary, founded in 1752, and he later established St Mary's Hospital. White was born in Manchester in 1728, the only son of Thomas White and his wife Rosamond. White joined his father's practice as an apprentice in around 1742, where he specialised in obstetrics. The house was later demolished to make way for the new town hall and the corner is now dominated by Lloyds Bank.

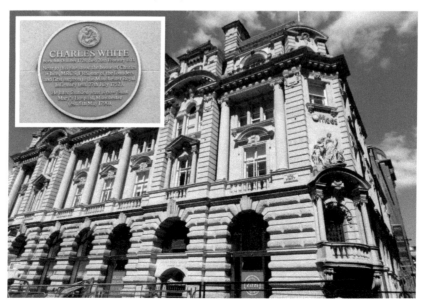

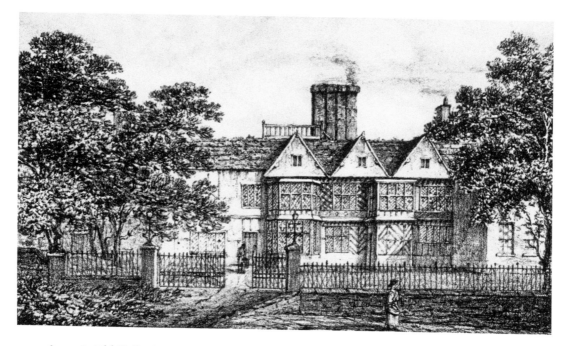

Ancoats Old Hall, 1822

The hall stood at the end of Great Ancoats Street, near Every Street. Oswald Mosley bought the land on which the hall was built in 1609. The house was sequestered by parliament after Oswald's son Nicholas Mosley supported the king in the Civil War but returned after a £120 fine was paid. It is said that Charles Edward Stuart possibly visited the town in disguise in 1744 and stayed with Sir Oswald Mosley at Ancoats Hall for several weeks. By 1827 it was owned by George Murray of nearby Murrays' Mills. He demolished the old hall and replaced it with a brick hall in the fashionable neo-Gothic style. The new hall was demolished in the 1960s after falling into disrepair. The map shows the hall surrounded by fields in 1794.

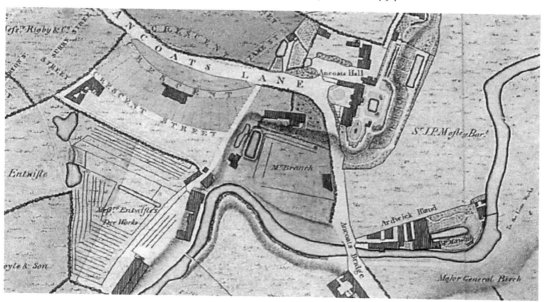

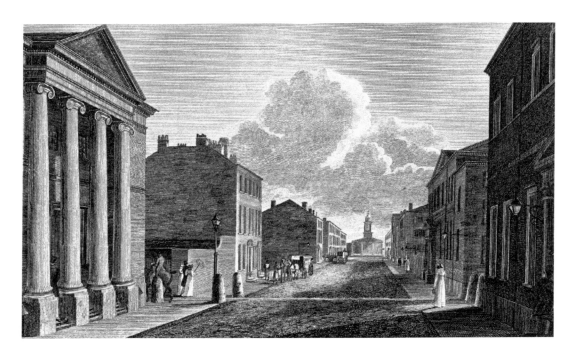

Mosley Street to St Peter's Church, 1824

An elegant view down Mosley Street. We see the Portico Library and the fine church beyond. St Peter's church was built in 1788 to serve the people who settled here on the outskirts of the relatively small Georgian town of Manchester. Built in the neoclassical style by James Wyatt, it was sadly demolished in 1907. A cross was erected in the square to mark the location of the church. The area is now being completely redeveloped to accommodate the new tram routes. The plan is to restore the cross and return it when building work is complete.

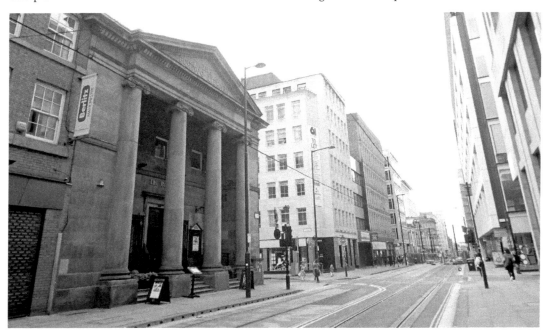

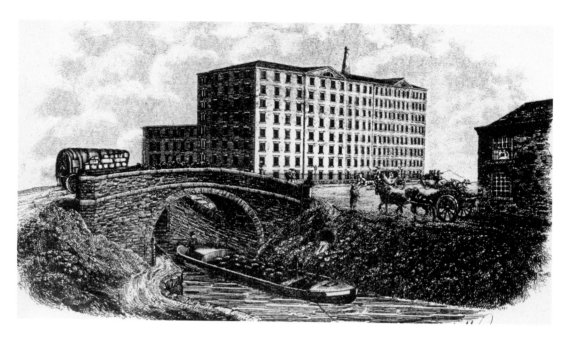

Pollard's Mill, Great Ancoats Street, 1825

Jonathan Pollard's son built this cotton-spinning mill in 1802, beside the newly constructed Ashton Canal. At eight storeys in height it was one of the largest mills in Manchester. The development of the canal network was a vitally important factor in the development of Ancoats, allowing transport of raw materials and finished goods as well as providing water for the steam engines powering the mills and factories. An archaeological dig before the building works began for the new Metrolink extension to Ashton uncovered remains of the early nineteenth-century mill and the adjacent Soho Iron Works.

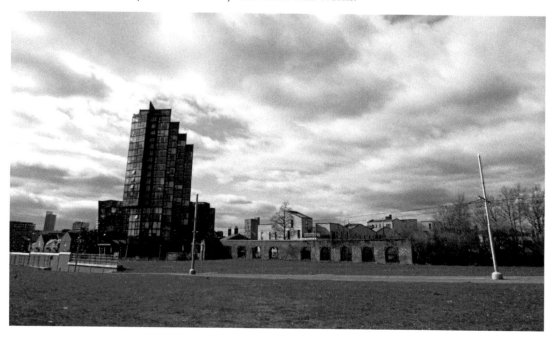

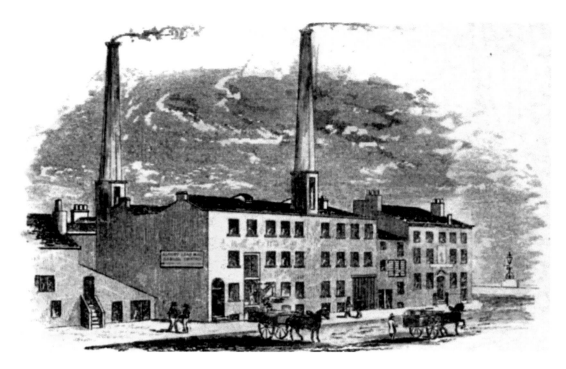

Alport Lead Mills, Deansgate, 1830

The image above shows a view of Georgian industrial Manchester. Samuel Gratrix established his lead mills in the Alport Town area between Watson Street and Deansgate, adjacent to the Manchester and Salford Canal. The business traded as lead, glass, oil, paint and colour merchants. The lead mills and most of Alport Town were swept away with the construction of the Great Northern Railway warehouse. Alport Lodge, the home of the Stanley family, stood close to St John Street. It was from here that Royalists fired cannon along Deansgate during the Civil War. The OS map below shows the area in 1896.

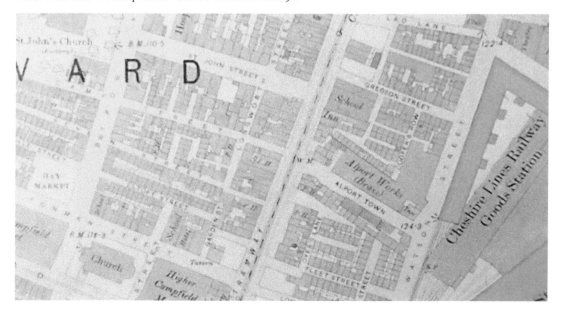

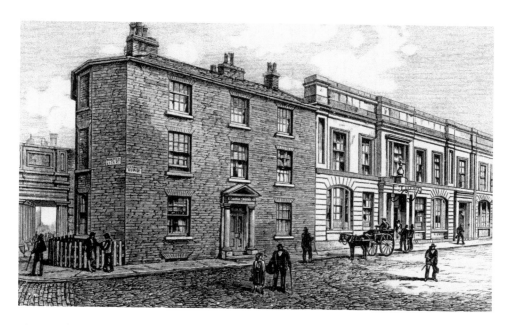

Liverpool Road Station, 1890

Liverpool Road Station ranked as one of the most important railway stations in Britain. Manchester can be said to have been the place where the railway age began. It was the service established between Liverpool and Manchester which first demonstrated the feasibility of rail as a viable transport system. Opened to the public in 1830, it marked the terminus of the newly created line which ran from Liverpool to Manchester, and it is now part of the Museum of Science and Industry. It was to this station that the Rainhill trials, to choose a locomotive to pull passenger coaches between Liverpool and Manchester, arrived. George Stephenson's 'Rocket' being the winner. The rail link, together with the canal system, was instrumental in the growth of Manchester's industrial base in the nineteenth century

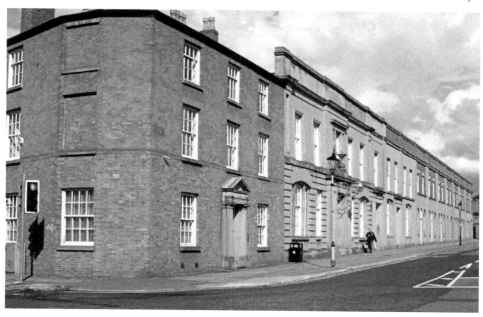

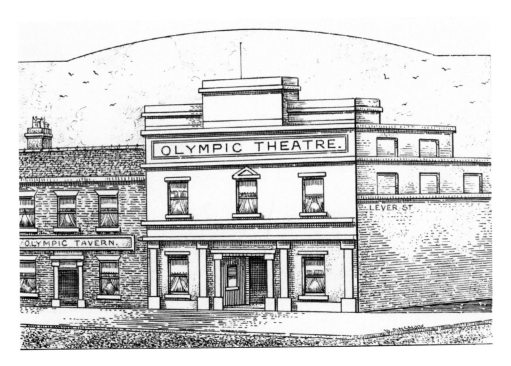

Olympic Theatre and Tavern, Stevenson Square

The Olympic was opened in 1838 and closed in 1841. It is perhaps not surprising it closed so soon. The local paper reported in 1838 that the sawdust arena was more suitable for an equestrian performance. A short play was acted every evening, but the performances were considered of a low quality. Bad luck dogged the theatre; in 1841 James Carter was seriously injured by one of his lions during the performance. The premises were purchased in 1842 by Messrs Faulkner, who turned it into a drapery store. Adhead's map shows the tavern still in business in 1851.

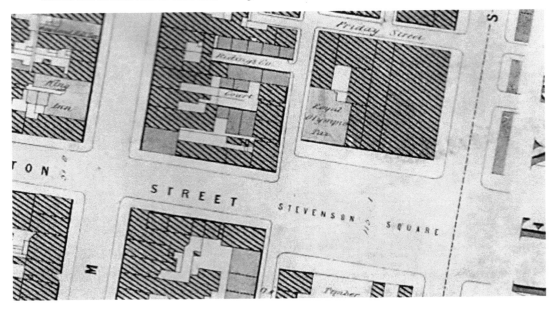

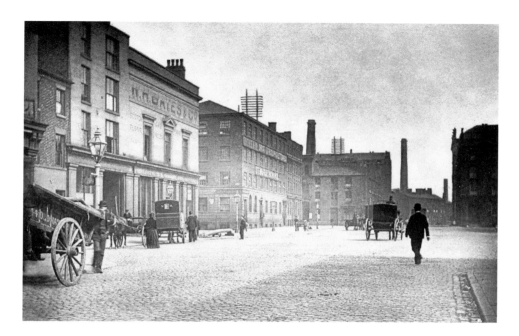

Stevenson Square, Lever Street, 1891

This is a much later view of the square. In the mid-eighteenth century, this area was owned by Sir Ashton Lever. Conceding to the pressure of property developers, Lever eventually sold the land to William Stevenson, who gave his name to the square. It was once the site of another church now lost to Manchester, that of St Clement, which was founded in 1793 and closed in 1879. The original intention was that it should become a residential area which would rival the serenity of St Ann's Square. Instead the area became the centre for the millinery and clothing trade and a popular place for open-air speakers.

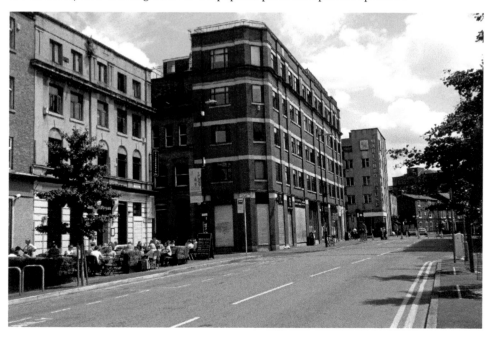

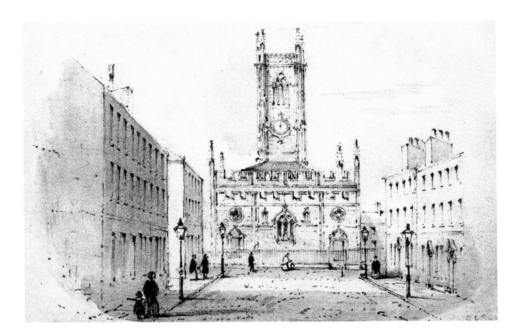

St John Street, 1850

Still the finest street in Manchester, St John Street boasts the only remaining complete set of Georgian terraces. The image above looks down towards St John's church. It is not known exactly when St John Street was laid out, but it takes its name from the church and it is reasonable to assume that the houses in the street were built as they were required, between 1770 and 1830. The church is shown on Tinker's map of 1772. Early residents represented a broad mix of occupations, but with the passage of time occupancy became almost exclusively connected with the medical and legal professions. Consultants and specialists still comprise the majority of occupants in St John Street.

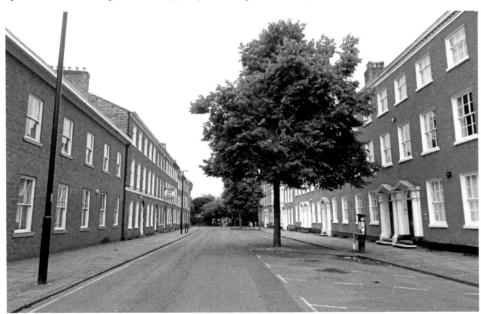

The Graves of St John's Church, Byrom Street, 1914

The Georgian church was founded by Edward Byrom in 1768, a wealthy entrepreneur, the son of John Byrom. He also built the first quay on the River Irwell, giving rise to the name of the nearby Quay Street. The churchyard contained the remains of a remarkable number of people associated with the rise of Manchester as a world industrial city. The church was demolished in 1931 and turned into attractive gardens. During the Jacobite uprising this area was used by Bonnie Prince Charlie as a gun park.

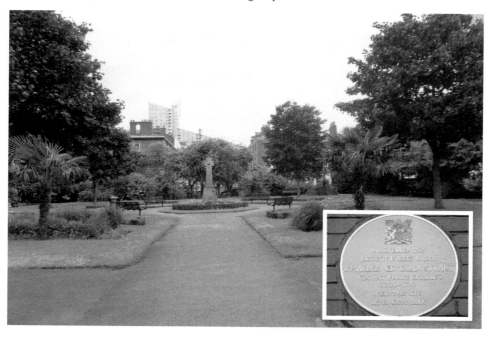

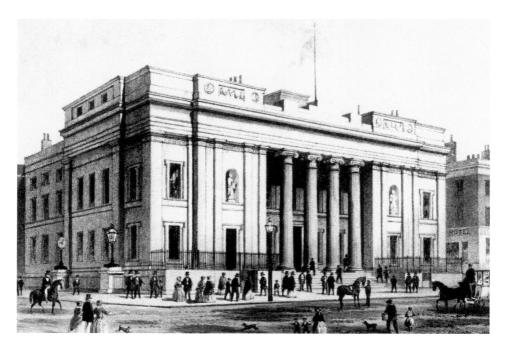

Town Hall, King Street, 1860

To reflect Manchester's new wealth, the town hall was built in 1822 on the corner of Cross Street. This site had been the home of Dr White. Designed by Francis Goodwin in the Grecian style it was strongly influenced by his patron John Soane. Next door, on the right, we can just see the York Hotel the site of anti-Corn Law meetings and where the first borough council met. As the size and wealth of the city grew even greater, a larger building was required and the town hall we see today was built in Albert Square.

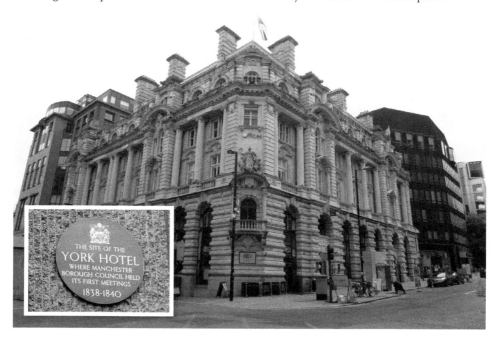

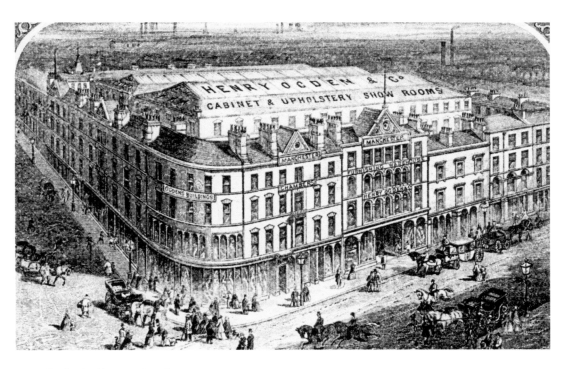

Ogden's, Deansgate, 1855

A striking view of the huge furniture warehouse and showroom that once occupied the whole block and ran back along both Bridge Street and King Street West. It was built for the cabinet maker Henry Ogden. The store attracted the many wealthy merchants of Manchester. We can still see parts of the original building today above Forsyth's music store.

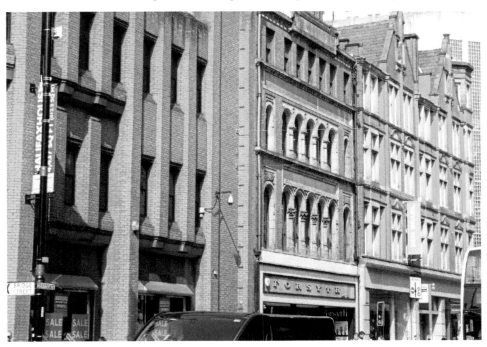

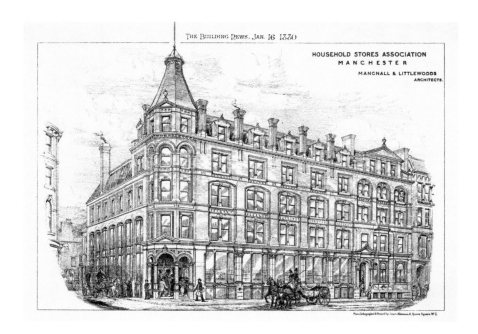

THE BUILDING NEWS. JAN. 16 1880

HOUSEHOLD STORES ASSOCIATION
MANCHESTER

MANGNALL & LITTLEWOODS
ARCHITECTS.

King Street West, 1880

This fine building was built for the Household Stores Association. Surprisingly the association was already in trouble in 1875 when the AGM was disrupted by complaints of written notice of the meeting not having been received by shareholders. There were complaints of discrepancies in the accounts and dividend payments were queried. The directors were accused of wilful and shameful neglect. Feelings were running high. To make matters worse Mr W. S. Lawn, secretary to the Lancashire and Yorkshire Railway, died during the meeting. Having just concluded his speech he was observed to faint. The association was voluntarily wound up in 1922. Now we see a favourite Italian restaurant – San Carlo.

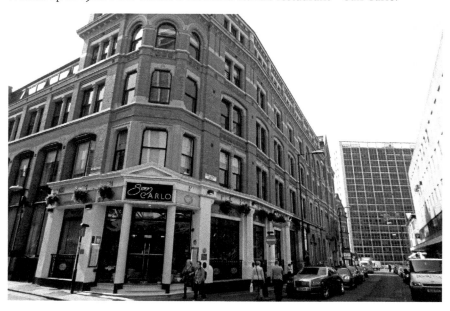

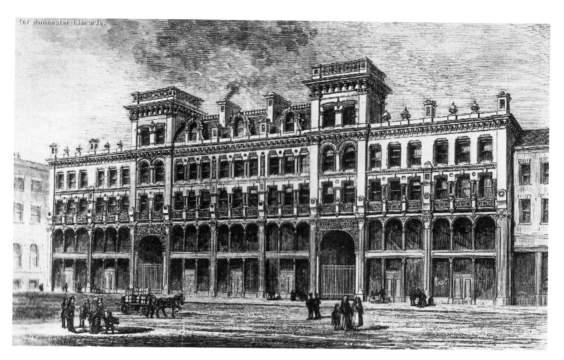

Deansgate, Barton Arcade, 1871
This fine building was erected in 1871. A gorgeous glass and iron shopping arcade. Pevsner says that 'it is probably the best example of cast iron and glass roofed arcade anywhere in the country.' It is believed to be influenced by the Galleria Vittorio Emanuele in Milan. Everything is light and airy with three tiers of balconies, and it is now a Manchester treasure. The modern shot shows the entrance from St Ann's Square.

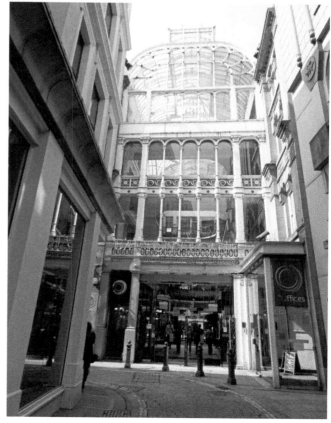

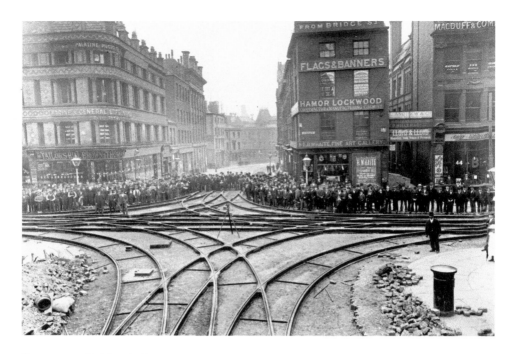

Deansgate, St Mary's Gate, 1901

Between 1901 and 1949 Manchester Corporation Tramways was the municipal operator of electric tram services in Manchester. Here we see the crowds watching the laying of the tracks. The first section of the reconstructed tramway, between Albert Square and Cheetham Hill, was opened for electric traction on 7 June 1901. Reconstruction and electrification was completed by 1903, and the last horse trams within the city ran in that year. The photo below shows the busy intersection today with the Renaissance Hotel on the right.

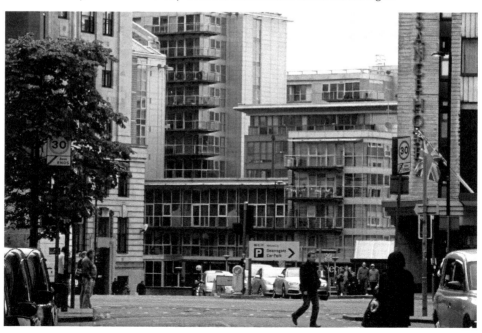

Golden Lion and Three Arrows, Deansgate, 1872
This part of Deansgate was completely transformed with the building of the Great Northern Warehouse when it was built about 1899. The Nantwich Fly Waggon Coach used to set off from the Golden Lion every Sunday morning at 7.00 a.m. The Three Arrows featured in a court case of 1892 when the publican, John Woodhead, viciously assaulted his wife. He was sentenced to twelve months imprisonment with hard labour. The warehouse has now been developed as the Great Northern Leisure and Cinema Complex.

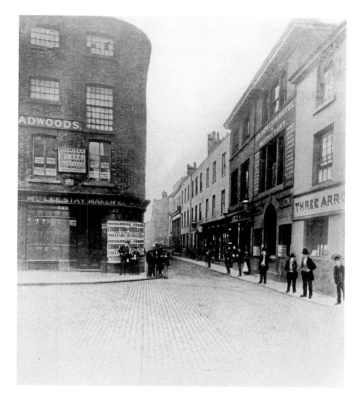

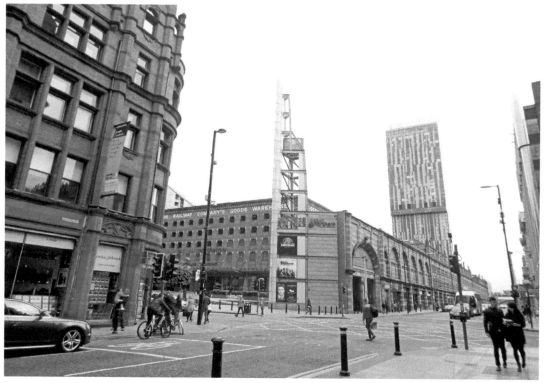

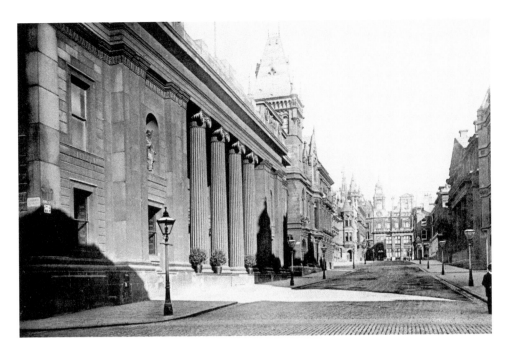

King Street, 1895

A fine view up King Street. In the photograph above, we see the town hall on the left, which by now housed the city library. The façade was removed to Heaton Park in 1912. This area of King Street had become the banking centre for the north-west of England. To the right we can just see the edge of the fine Bank of England, built in 1845 and designed by Charles Cockerell. The town hall site is now occupied by the Lloyds Bank building. Built in Portland stone it was completed in 1915.

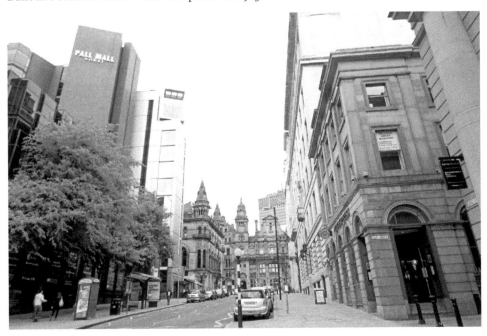

Deansgate, 1900
The photograph above shows a very sombre corner of Great Bridgewater Street in 1900 looking down towards 'The Britons Protection'. Ind Coope breweries Burton-on-Trent are advertising on the second bridge. Nowhere better illustrates how Manchester has been transformed, the corner now dominated by The Beetham Tower, a huge forty-seven-storey hotel and apartment block, standing 270 metres high that is the tallest building in the city. The Hilton Hotel opened in 2006, and the first apartment residents moved in during 2007. The skyscraper cost £150 million to construct.

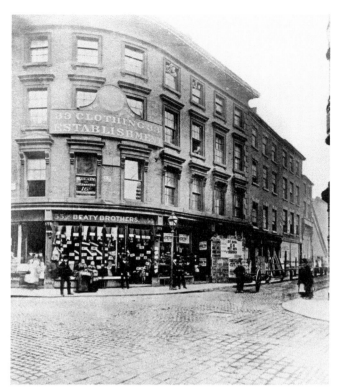

Deansgate, Beaty Bros, 1885
This corner of Deansgate on the corner of St Mary's Street was dominated by Beaty Bros, the famous tailors in Manchester. They had shops in Oldham Street and at the Royal Exchange. The company went into voluntary liquidation in 1944. Kendal's main store was built in 1939, by J. S. Beaumont and was connected below Deansgate by a tunnel. Now a House of Fraser store, behind it we can see Arkwright House, which was built in 1937 for the English Sewing Cotton Co.

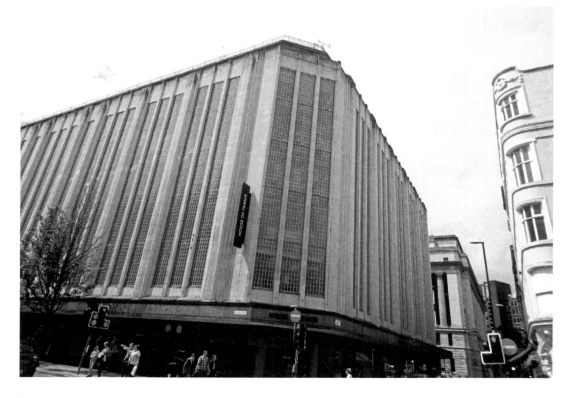

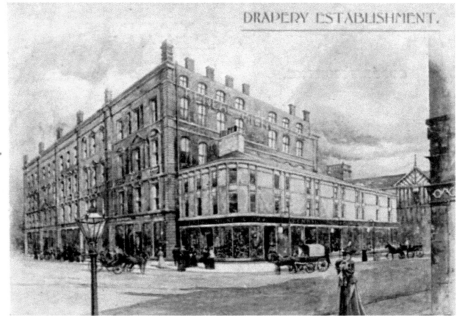

DRAPERY ESTABLISHMENT.

BY APPOINTMENT.

Kendal,
Milne
& Co.,
Manchester

Silk
Mercers
&
General
Furnishers,

TELEGRAMS:
"Kenmil,"
Manchester.

TELEPHONE:
1746,
Manchester.

Deansgate, Kendal's, 1910

A charming advert for Kendal Milne – a Manchester institution. The shop was founded by John Watts in 1796 when he opened a store on Deansgate. In 1835 the business was sold to three of Watts' employees. Thomas Kendal had trained as a draper in London, James Milne and Adam Faulkner had both been apprenticed in the textile trade. The store traded at first as Kendal Milne & Faulkner. This view shows the drapery department which was on the opposite side of the road from the main store, where Waterstone's stands today.

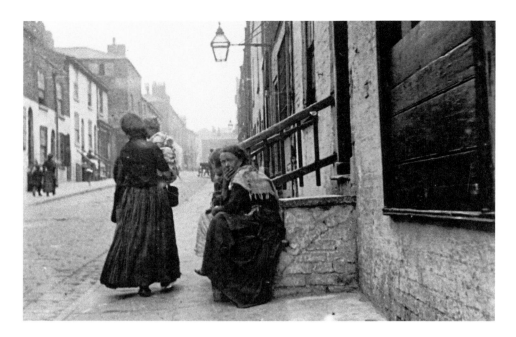

Angel Street, Angel Meadow, 1860

Despite its name, this area at the bottom of Rochdale Road was home to the poorest of the city. Angel Street leads down to the River Irk and it is not surprising that a cholera epidemic struck in 1832. By 1881, the census showed that 1,091 inhabited dwellings in the area were all unsanitary and infested with vermin. St Michael and All Angels' church was built here in 1788. Twenty years later *Manchester Guardian* declared 'Why one of the ugliest churches in Manchester, situated in one of the most crowded and notorious parts of the city, should have so long enjoyed the pleasant sounding name St Michael's Angel Meadow, is beyond understanding.' This historic site is now a steeply sloped park dotted with trees.

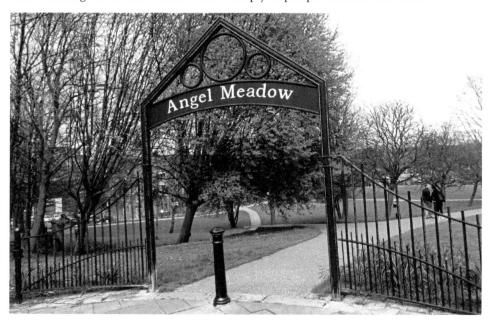

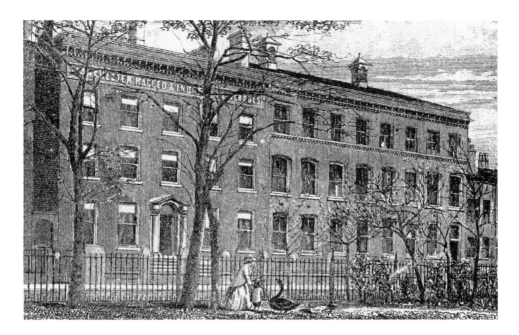

Original Ragged School, Dantzic Street, 1860

The original industrial school was opened in 1847. The present building was first used in 1866. In 1892 it was renamed as the Charter Street Ragged School and Working Girls' Home. It provided food, clogs and clothing for children, and a Sunday breakfast for destitute men and women; medical services were also provided. The working girl's home was on the top floor with its own separate entrance on Dantzic Street. The industrial schools were intended to convey not only literacy but basic skills such as carpentry to the boys, and home making and cooking to the girls. On a red-hot day in July 1900 the school was visited by the Duchess of Sutherland, following a line of many well-meaning dignitaries including Winston Churchill and General Booth.

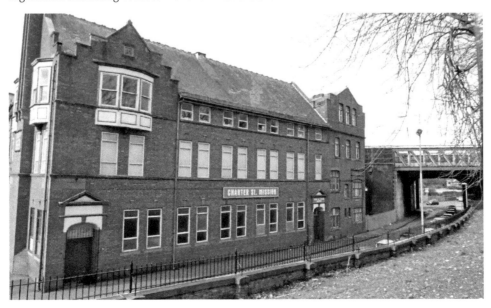

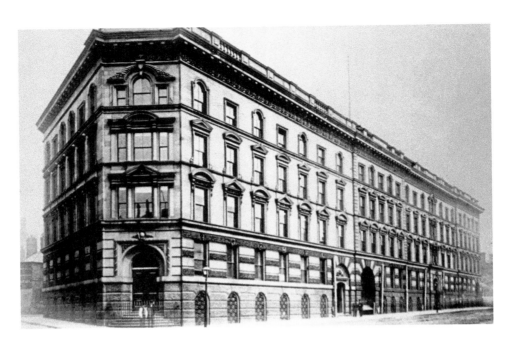

Pender's, 1866

This fine warehouse was built by John Pender. He not only became a merchant of renown in Manchester, he also financed the first telegraph across the Atlantic, and founded the telecoms giant Cable and Wireless. After attending school in Glasgow he became a successful merchant in textile fabrics. Knowing the importance of Indian cotton to the mills of the North of England, he came to Manchester and built this large warehouse. The *Manchester Guardian* of 1857 reported 'an appalling accident at John Pender's on Mount Street' – a man had died and others were badly injured. Fortunately, the inquest found the company not responsible for the accident.

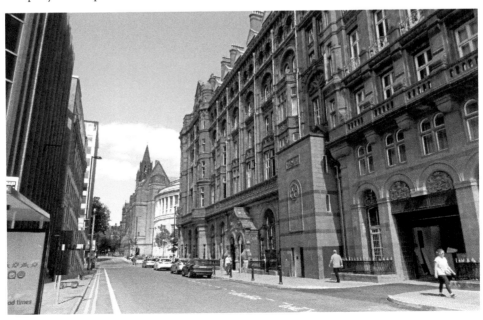

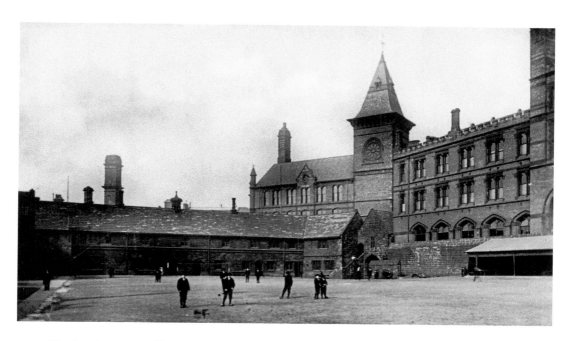

Chetham's, Long Millgate, 1910

The school was built on the site of Manchester Castle, a fortified manor house owned by the Grelleys after the Norman Conquest. Medieval Manchester grew around the manor house and the parish church. The oldest parts of the school date to the 1420s, when the building was constructed as a residence for priests of the church now Manchester Cathedral. Founded as a charity school by Humphrey Chetham. The site houses Chetham's Library, the oldest public reference library in the United Kingdom and The School of Music. Hugh Oldham founded the original Manchester Grammar School nearby before its move to Fallowfield in 1931.

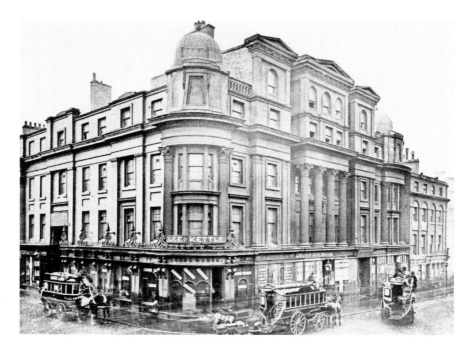

Newall's Building, Royal Exchange, 1867

In 1852 the building became the headquarters of the Anti-Corn Law League. The first exchange was opened in 1792 as a meeting place for the businessmen of Manchester. In 1809 a larger building was built on the same site. A third exchange, which extended over Newall's building, was opened in 1874. This had a fine classical portico on Cross Street. Membership was declining with the demise of the cotton trade and trading ceased by 1961. The board showing final prices can still be seen in The Royal Exchange Theatre.

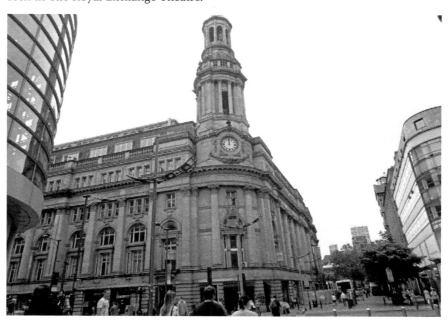

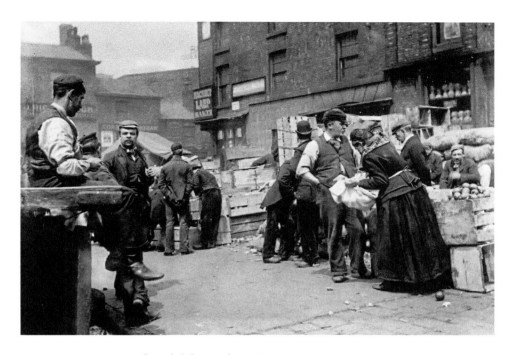

Swan Street, Corner of Rochdale Road, 1900

This corner was the site of the Swan Street hospital. During the cholera epidemic of 1832, the hospital treated 443 cases of which 234 died. It was the scene of a major riot following the discovery of human remains. They believed the body of a boy had been mutilated but it was probably undergoing a post mortem. By 1900 the hospital is gone and we see the market traders busy at their stalls. The Rochdale Road corner is now dominated by the magnificent head office of the Co-operative Group.

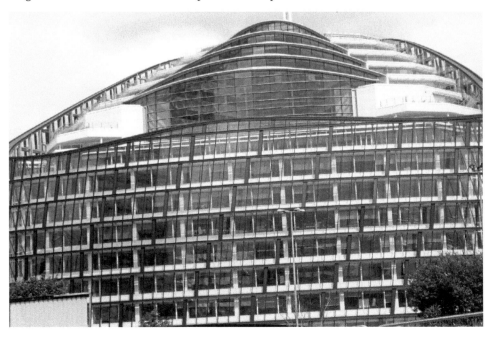

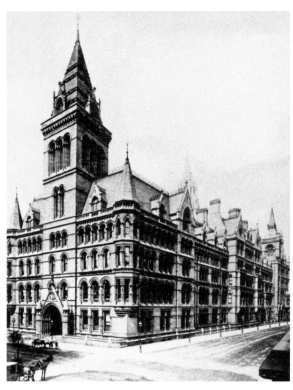

Town Hall, 1877
A view of the rear of the town hall.
It was designed in Gothic style
by Alfred Waterhouse. His design
incorporated such innovations as
a warm air heating system. He
ingeniously concealed the gas pipe,
which carried the gas for the lighting,
underneath the banister rails of
the spiral staircases. The building
was brand new when this photo
was taken. The Peace Garden we
now see was developed to celebrate
Manchester's role as a 'City of Peace'.

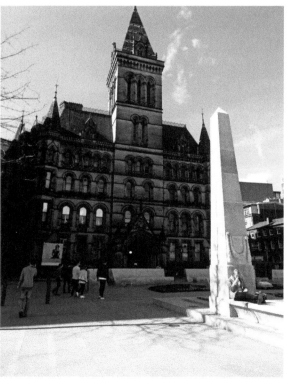

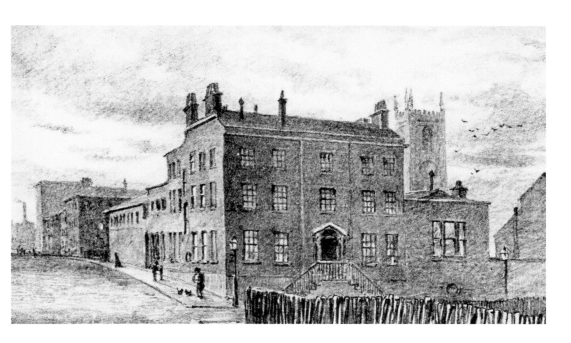

Owens College, Quay Street, 1880

Richard Cobden (1804–65), the politician and reformer, lived in this Georgian house on the corner of Quay Street and Byrom Street. It was later purchased under the will of John Owens, a wealthy textile merchant, and opened as Owens College in 1851. Later still, it became the Victoria University of Manchester. From 1878 until 1990, the house was used as the county court. John Owens, with his parents and brothers were buried in St John's churchyard. In the 1770s, the site was owned by the family of Edward Byrom (hence the name Byrom Street).

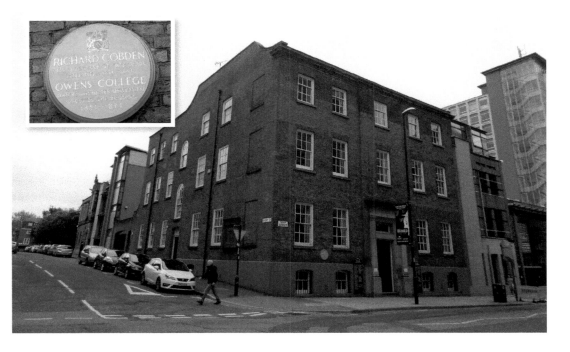

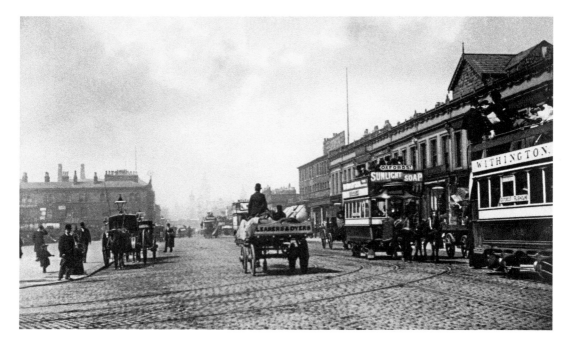

All Saints, 1890

The area is named for the fine church which stood in the gardens to the left. Heavy damage during The Manchester blitz resulted in its demolition. The view down Oxford Road reminds us of the paintings of Manchester by Adolphe Valette (1876–1942). He was born in the industrial town of St Etienne in France and came to England in 1904. He settled in Manchester and studied at the Manchester School of Art where he later taught between 1906 and 1920. Among his students was L. S. Lowry.

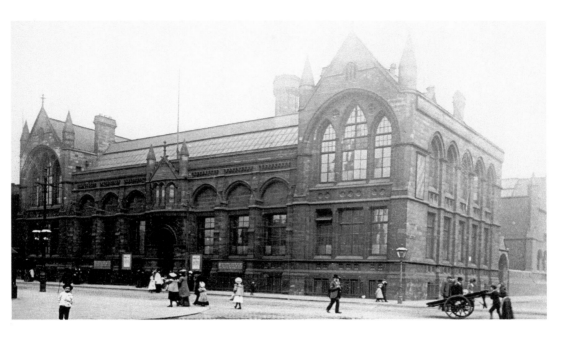

Art School, Cavendish Street, 1900

Manchester School of Art was established in 1838 as the Manchester School of Design; it became the School of Art in 1853 and moved to Cavendish Street in 1880. It was subsequently named the Municipal School of Art. In 1880, the school admitted female students; at the time, the only higher education available to women, although men and women were segregated. The school was extended in 1897. The school is perhaps most famous as the college of L. S. Lowry, though it had other famous students including Sylvia Pankhurst, Ossie Clark, Martin Parr, Malcolm Garrett, Peter Saville and Thomas Heatherwick. When founded, the school promoted the Arts and Crafts movement's philosophy and its collection includes metalwork, jewellery, wallpapers, and a tapestry made by Morris & Co. which was designed by Edward Burne-Jones.

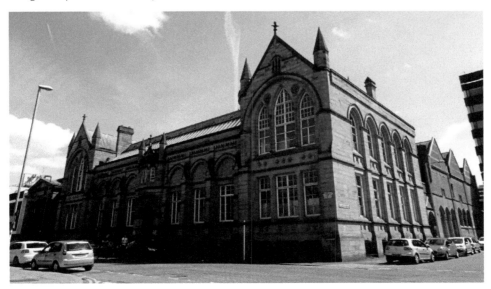

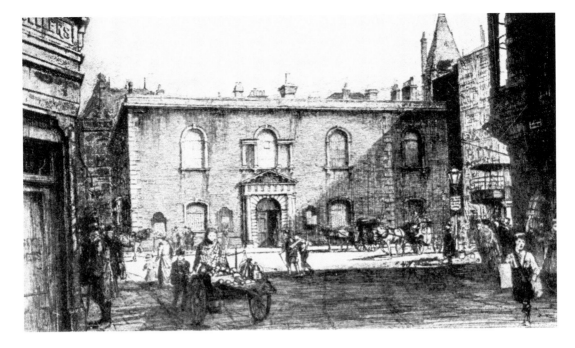

Cross Street Chapel, 1890

The home of the Unitarian church in Manchester. Unitarianism as an organised church grew out of the Protestant Reformation of the sixteenth century, the church was founded in 1694 and wrecked by a Jacobite mob in 1715. In 1828 William Gaskell, the husband of Elizabeth Gaskell, became its minister. When he completed fifty years of his ministry at Cross Street in 1878 there was a soirée in Manchester Town Hall attended by over 1,000 people. The fine building we see in the photo was destroyed during an air raid in the Second World War in December 1940. A new building was constructed in 1959 and the present structure dates from 1997. The Gaskell Room of the new building houses a collection of memorabilia of novelist Elizabeth Gaskell.

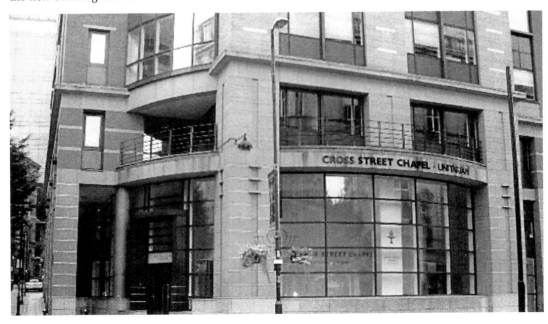

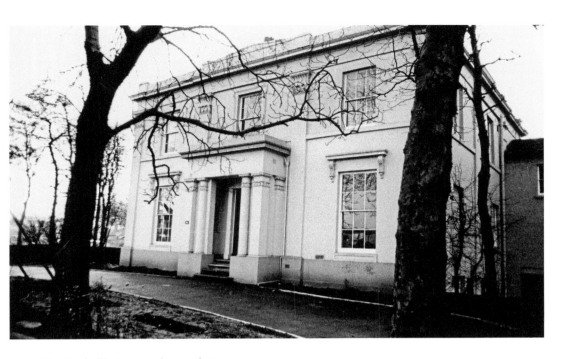

The Gaskell's Home, Plymouth Grove

Elizabeth Gaskell was one of the best loved Victorian writers. Her novels often reflected the social tensions of the day. The Gaskells were committed to helping the poor in Manchester. They worked tirelessly towards working class education and the Mechanics' Institute movement. She lived at this house with her husband William and their daughters from 1850 until her death in 1865. The family remained here until 1913. The house has been beautifully restored and is now open to the public.

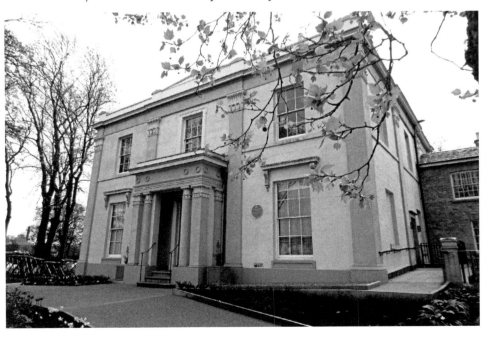

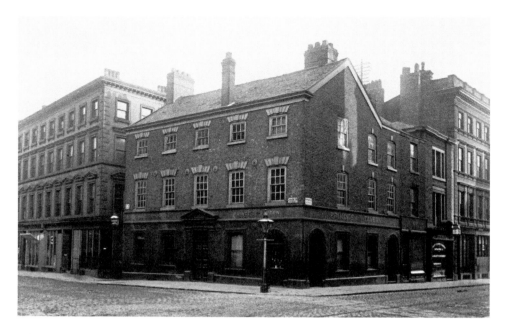

John Dalton Street, 1892

Thomas De Quincey was born here in 1785; he has since become known for his work *Confessions of an English Opium Eater*. Along with his opium addiction, debt was also a problem. He became an acquaintance of Coleridge and Wordsworth, having already sought out Charles Lamb in London. His acquaintance with Wordsworth led to his settling in 1809 at Grasmere, in the Lake District. His home for ten years was Dove Cottage. The building became Princes Tavern and the office building is named De Quincey House today.

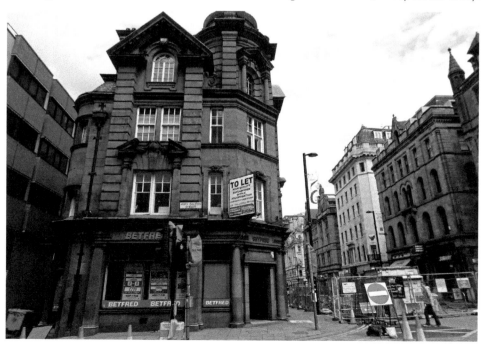

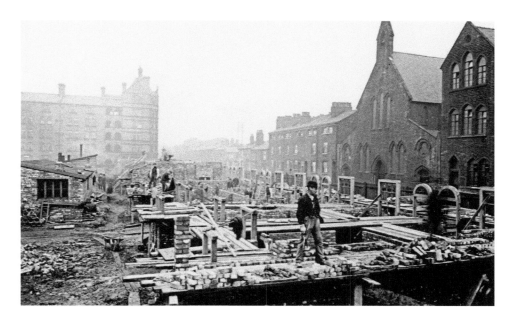

George Leigh Street, Ancoats, 1898

The building of George Leigh Street and Anita Street. The land had been owned by the Leigh family giving the street its name. These houses were built to a high standard for working-class houses of the time. Pevsner says of them that they were three-bedroomed dwellings that 'conform to the moral idea for housing'. Built by the Manchester Corporation following the act that required councils to provide accommodation with separate bedrooms for girls, boys and parents. Beyond we see the imposing Victoria Square, the first municipal housing, completed in 1894. On the right we see Saint Michael's Roman Catholic church. Founded in 1858 the church became the heart of the Little Italy Community in Ancoats. When it closed, parishioners continued to hold masses outside the church and campaigned for its reopening.

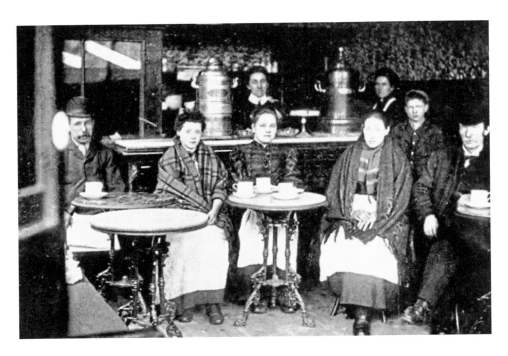

Ancoats Women's Shelter, 1893

The Methodist Women's Night Shelter, on the east corner of Great Ancoats Street and George Leigh Street. It was opened in 1899. We see the coffee tavern on the ground floor, the rest was divided between a night shelter, a home for women needing 'further care and discipline' and a home for domestic servants, who were being offered an alternative to the moral perils of the lodging house The photo shows the women looking proud. The fine building still stands today next to the attractive Hudson Buildings. Built in 1924 as a warehouse these have since been converted into flats.

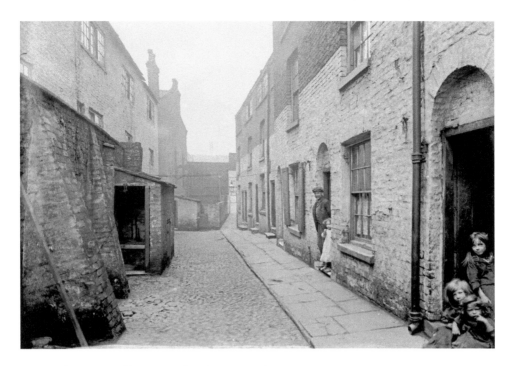

Pearson's Court, Off Corporation Street, 1908

Although this is a quote about Angel Meadow it fits nearby Pearson's Court equally well:

> The houses of the poor ... are too generally built back-to-back, having therefore only one outlet, no yard, and no receptacle of refuse. Consequently the narrow, unpaved streets, in which mud and water stagnate, become the common receptacles of offal and ordure.

The map of 1851 shows the density of housing between Miller Street and Hanover Street. By 1908 some improvements had been made, but it was still a harsh place to live.

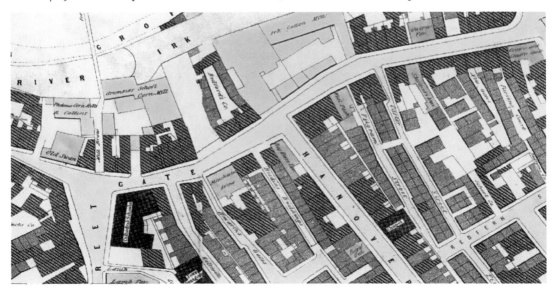

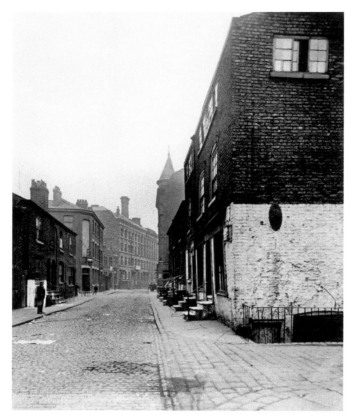

Ancoats, Blossom Street, 1901

Many Italians settled in Ancoats in the 1880s and for the next 100 years they created what became known as 'Little Italy'. Many of them found work in the mills but many continued their tradition of ice-cream making. It was in Blossom Street that the ice plant was built for the Italian ice-cream makers, seen here in the centre of the photo. The area has been developed and the former ice plant is now an attractive apartment block. We can also see The Edinburgh Castle pub, which is now closed, was once a very busy Ancoats pub.

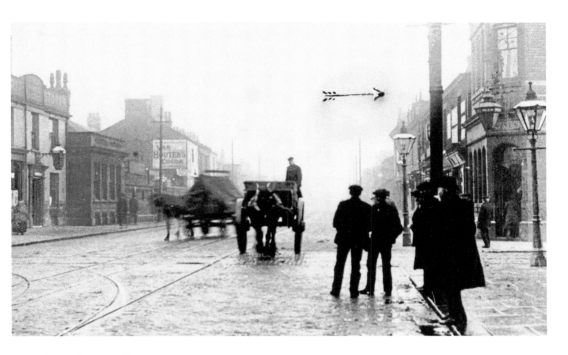

Great Ancoats Street, 1900

Ancoats Lane, along the north-east boundary of the conservation area, was originally a cart track leading from Shudehill to the cattle drovers' highway, Ashton Old Road. By 1788 it was renamed Great Ancoats Street, reflecting its increased economic importance. Friedrich Engels described nineteenth-century working-class housing in Great Ancoats Street as 'ruinous' rows of 'back-to-backs' among the towering mill buildings. Unsurprisingly, the area became a centre for the Chartist movement in the 1840s. The arrow on the picture shows the Griffin Inn, once known as the Chartist's boozer.

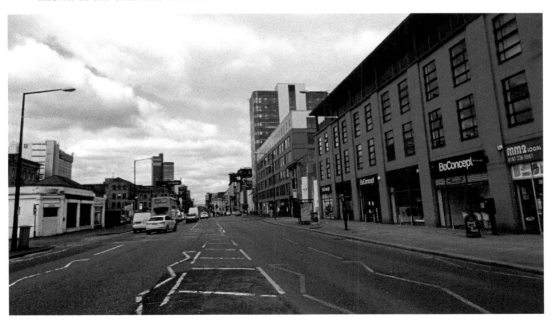

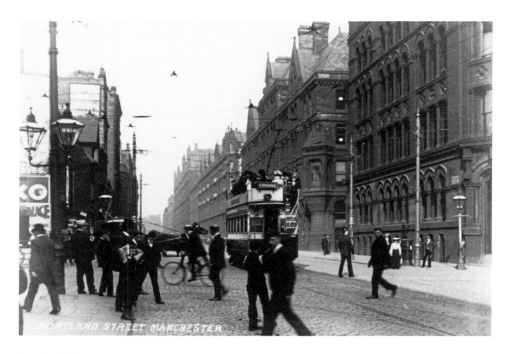

Portland Street, 1905

Looking up towards Watts' warehouse now the Britannia Hotel. This was the largest wholesale drapery business in the city. There were seven warehouses on Portland Street when the elaborate Watts Warehouse of 1855 was begun and four more were opened before it was finished. The square mile of 'warehouse city' has been described as the finest example of a Victorian commercial centre in the United Kingdom. Many of the fine warehouses still stand today.

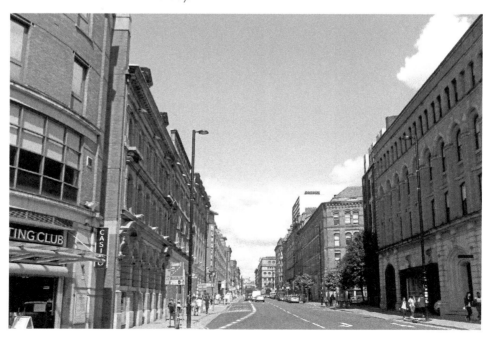

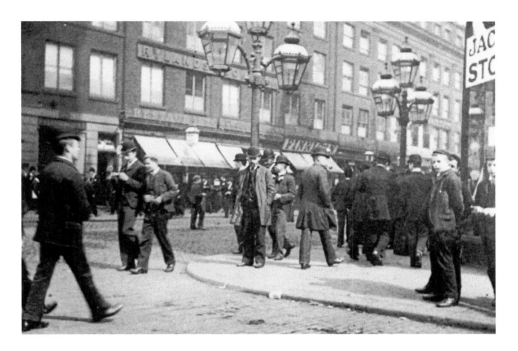

Market Street from Fountain Street, 1900

The corner is now dominated by Debenhams. Rylands building was designed in 1932 in an art deco style. It was originally built as a warehouse by the Rylands textile company. which was founded by John Rylands. He was Manchester's first multi-millionaire, he employed 15,000 people in his seventeen mills and factories. His wife ensured that his name would live on forever in Manchester, when she founded the John Rylands Library on Deansgate.

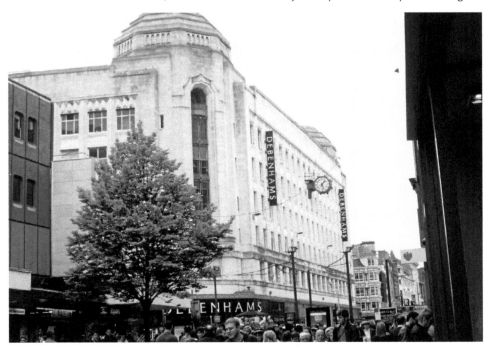

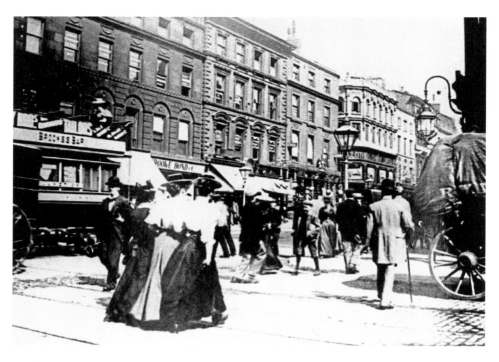

Market Street from Cross Street, 1900

Another busy scene on Market Street, taken beside the Royal Exchange on the corner of Cross Street. The shops were all demolished to build the Arndale Centre in 1972. The shopping centre was never popular from a visual point of view. This corner was badly damaged by the IRA bomb of 1996, though has now been rebuilt.

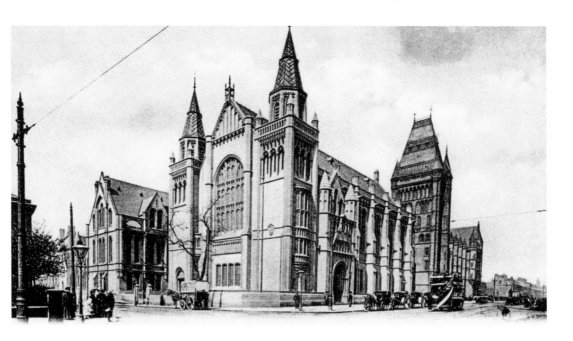

University Whitworth Hall, 1903

Most of what we see is down to the legacy of Sir Joseph Whitworth. In 1841, he devised the British Standard Whitworth system, which created an accepted standard for screw threads. He also created the Whitworth rifle, often called the sharpshooter. Money from his will was used to build Whitworth Hall, which completed the front quadrangle of Owens College. The Whitworth Art Gallery and Whitworth Park were established as part of his bequest to Manchester after his death. The nearby Whitworth Park halls of residence also bear his name, as does Whitworth Street.

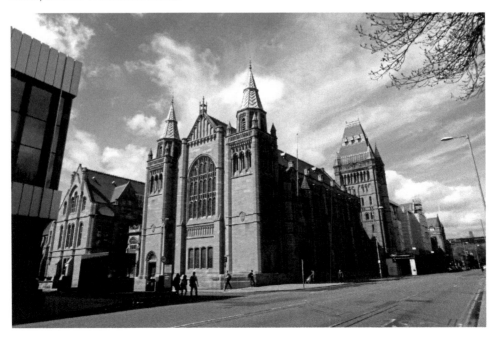

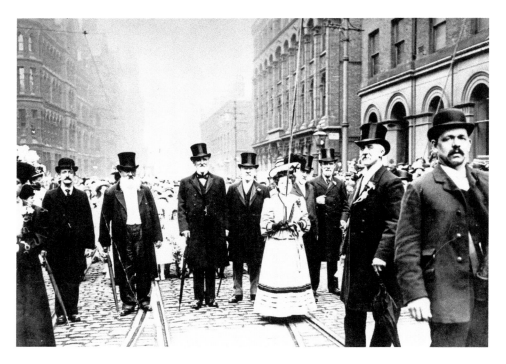

Whit Walks, 1903

The photograph above shows one of the popular Whit walks on Princess Street near Mosley Street. Manchester's Whit walks were once a large part of Manchester life. Huge crowds gathered on Whit Monday to see the Anglican churches and on Whit Friday to see the Catholic churches. The tradition lives on. Here we see the procession on Bank Holiday Monday walking along Deansgate from the cathedral to Albert Square.

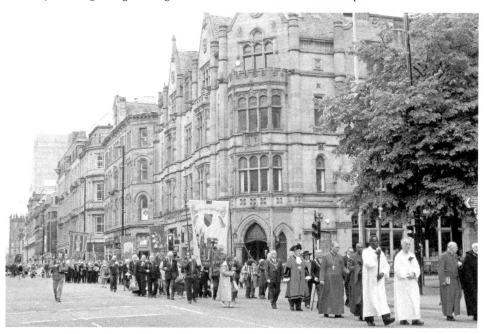

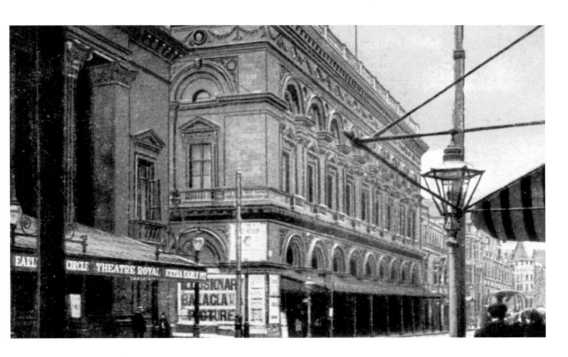

Free Trade Hall, Peter Street, 1905

Richard Cobden gave land to build the original Free Trade Hall. The hall we see today was the third hall built on this site. It was completed in 1856 and dedicated to free trade and all those who fought for the repeal of the Corn Laws. In 1940, the hall was damaged by a bomb and the inside was later remodelled. It was opened as a concert hall in 1951 and became the home of the Hallé orchestra, until Bridgewater Hall was opened in 1996. The hall is now a fine hotel and the Theatre Royal (next door) is now a night club.

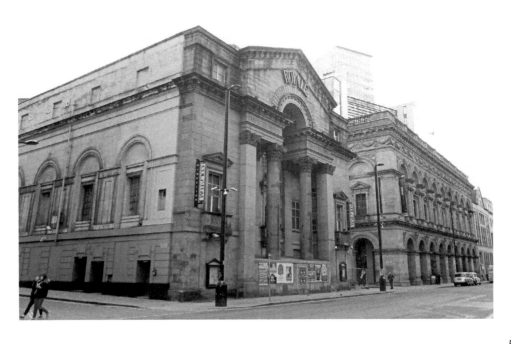

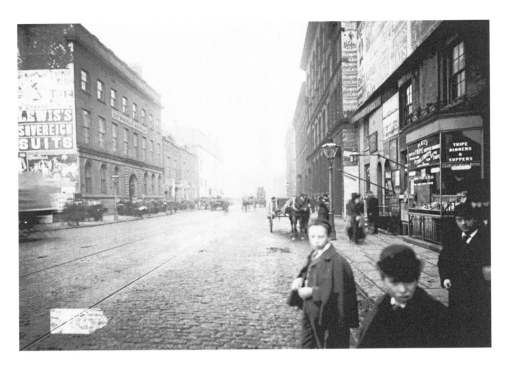

Lower Mosley Street, 1905

Looking towards St Peter's church. On the left we see the Day and Sunday Schools. The Gaskells were heavily involved with the Lower Mosley Street Schools, set up by the congregation to meet the needs of working class children in basic education as well as in religious instruction. Both of them taught in the schools. The whole block was demolished for The Midland Hotel.

Jacksons Row, 1908

The lower building on the left is now the site of the Old Nag's Head pub and opposite we see Dodd's Coal Merchants. This corner of Deansgate was the site of an early Friends Meeting House built in 1732. The modern photo shows Eliot House the former school board offices built in 1878. Later the registry office and recently the temporary home of the city library until it reopened in St Peter's Square.

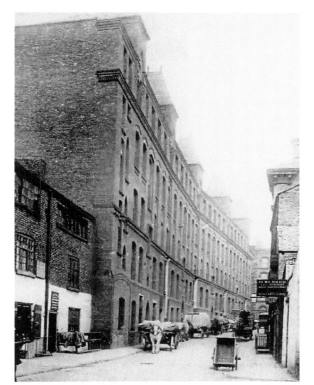

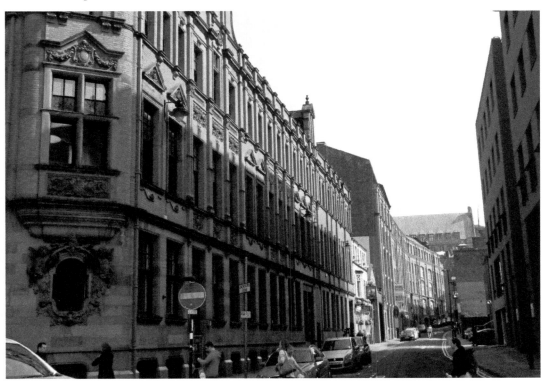

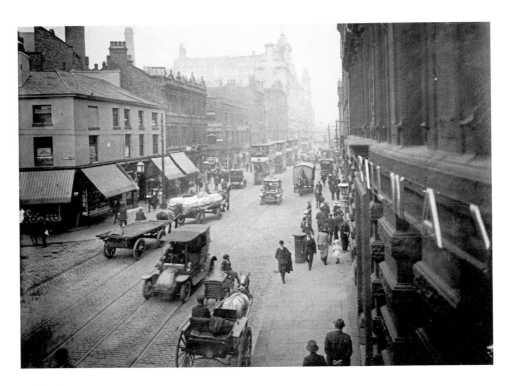

Oxford Street 1913

A busy scene before the war taken from the corner of George Street, all the buildings on the right are now demolished. Oxford Place can be seen on the corner of Portland Street, just before the St James buildings on the left. The modern photo was taken from the top floor of the central library.

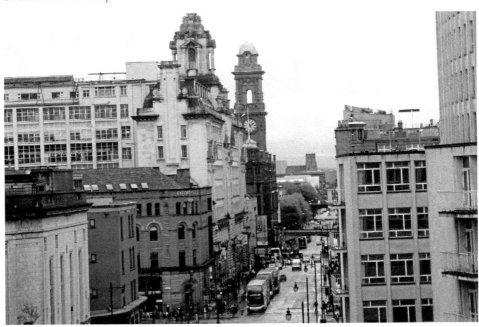

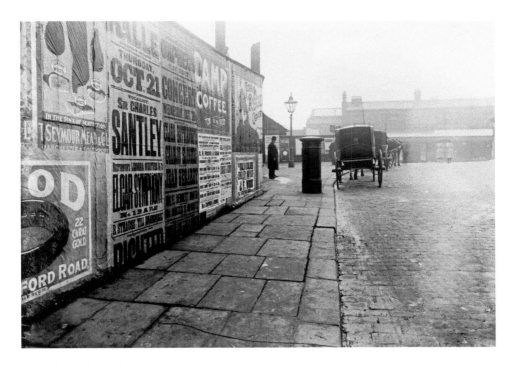

Oxford Road, Station Approach, 1909

The station was opened in 1849 by the Manchester, South Junction and Altrincham Railway. The station was the headquarters of the MSJAR from its opening until 1904. The approach to the station is dominated by adverts for the Hallé, Manchester Orpheus Glee choir, Turkish cigarettes and Camp coffee. We see hansom cabs waiting for customers. The modern shot shows the Corner House and the station, which is now dominated by the Student Castle.

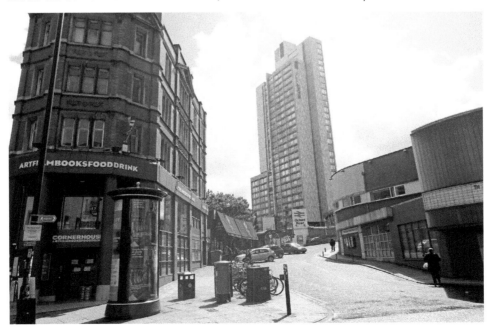

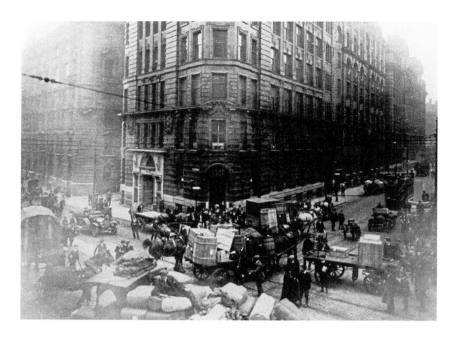

Whitworth Street and Princess Street, 1914

Princess Street and Whitworth Street are both impressive Victorian streets that are still lined with warehouses today. This view of the busy corner demonstrates the problems of transporting goods by horse and cart. Quite a traffic jam! If you look closely you can see a policeman in the middle trying to create some order. The photo must have been taken near the bridge over the Rochdale canal. The Union Bank on the corner is now the premises of the Royal Bank of Scotland. This area by the canal is now the busy gay village.

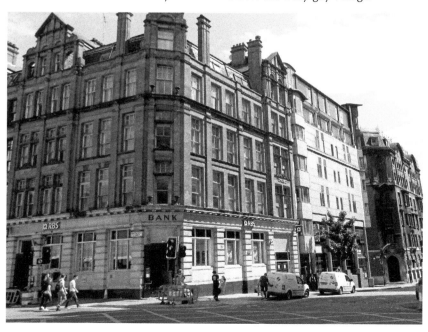

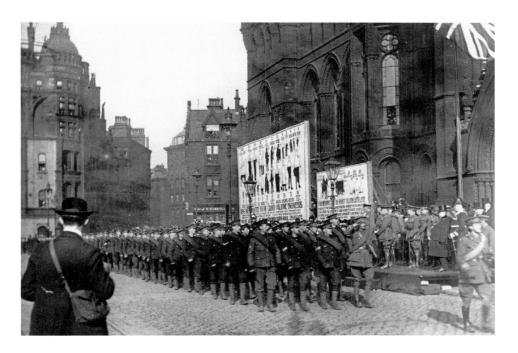

Albert Square, Kitchener's Parade, 1915

In March 1915 Lord Kitchener reviewed a parade of troops in Albert Square. During the visit, which only lasted ninety minutes, he saw 13,000 South-East Lancashire troops. Many of them were far from battle-ready. The famous poster featuring him beckoning 'Your Country needs YOU' resulted in 2,466,719 men volunteering between August 1914 and December 1915. Albert Square is still an important focal point for marches. Here we see the square as the destination of the Whit walks.

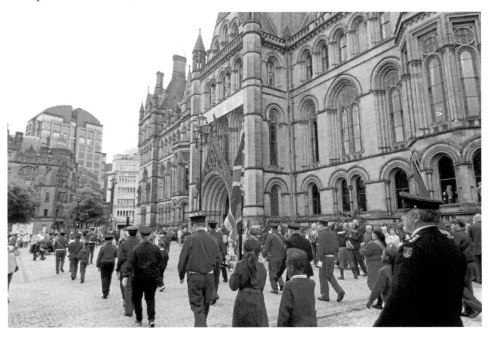

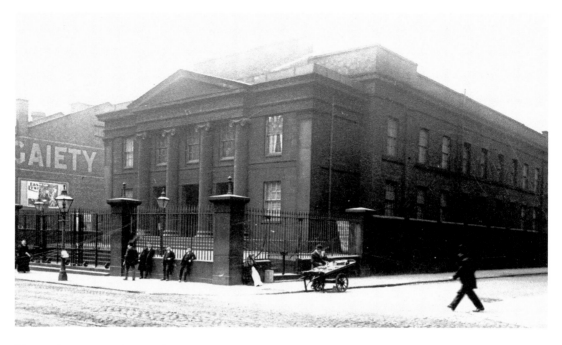

Mount Street Friends Meeting House, 1915

The Quakers have existed in Manchester since the time of George Fox, who visited the town in 1647, and again in 1657. Quakerism gained a considerable following in England and Wales, and the numbers increased to a peak of 60,000 in England and Wales by 1680. The first Quaker meeting house to be built on the current site at Mount Street was built in 1795. This building was designed in 1828 by Richard Lane, a Quaker Architect, whose pupil was Alfred Waterhouse. The cost of the building, £7,600, was raised by subscription from local Quakers, one of whom was John Dalton, the famous chemist and discoverer of atomic theory who worshipped here for many years.

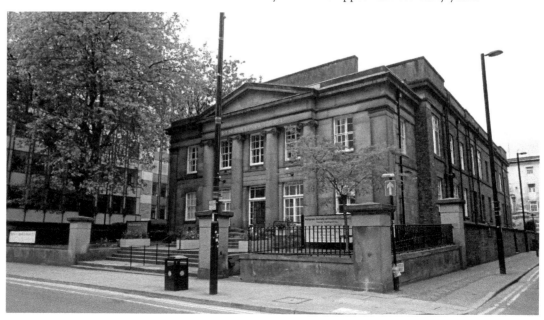

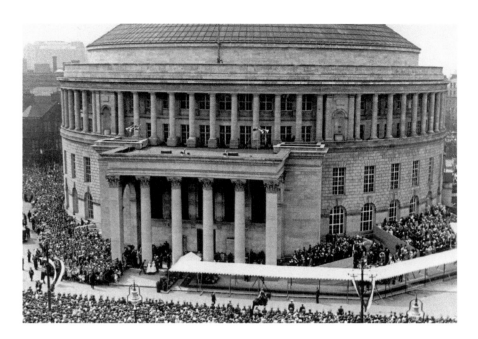

Central Library Opening, 1934

Manchester was the first authority to open a free public library after the Public Libraries Act of 1850. It opened at Campfield in 1852 at a ceremony attended by Charles Dickens. The library was moved to the old town hall in King Street and later to Piccadilly Gardens. In 1926 the city council held a competition to design an extension to the town hall and a central library. E. Vincent Harris was selected to design both buildings. The library's foundation stone was laid on 6 May 1930 by the Prime Minister Ramsay MacDonald. The library was officially opened by George V on 17 July 1934. The library has now been transformed to meet the needs of the twenty-first century.

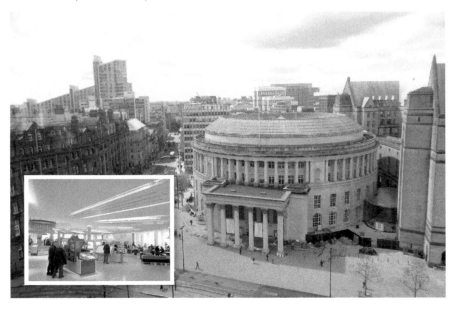

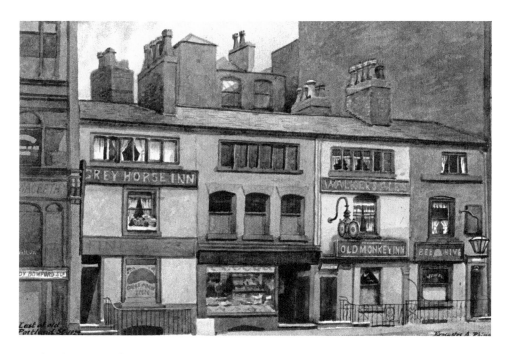

Portland Street Pubs, 1924

In 1888 this terrace was home to no less than five public houses. The Old Monkey stood in the terrace. It has now been rebuilt on the corner site of The Queens Arms which closed in 1925, having been open since 1841. We can still see The Grey Horse Inn, on the right, a single-roomed old pub, probably converted from early nineteenth-century weavers' cottages and another tiny pub, The Circus Tavern. Believe it or not, apparently a circus used to stay over winter on this block.

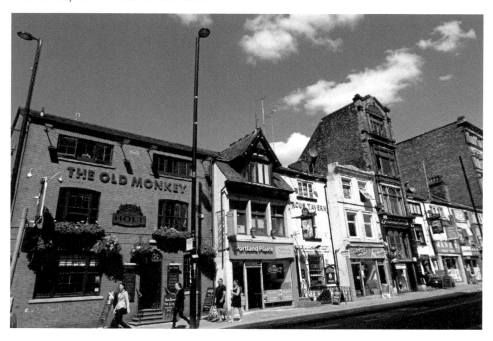

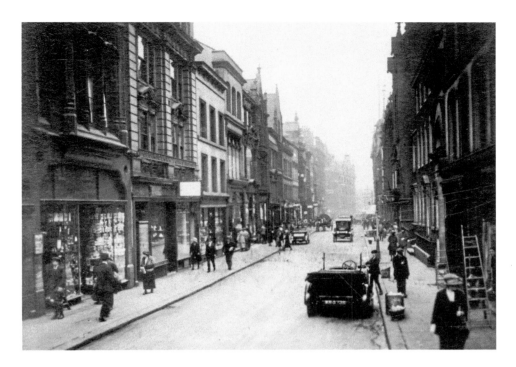

King Street, 1930

Looking down towards Deansgate. The south part of King Street is now mainly shops. We can still see on the right, the last surviving Georgian mansion in central Manchester. It was built as a residence in 1736 by Dr Peter Waring, and became a bank soon after his death in 1788. Now a branch of Jack Wills. Although, still a fashionable shopping street, it now has a rival in Spinningfields.

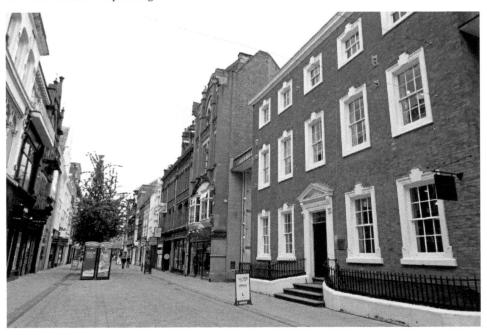

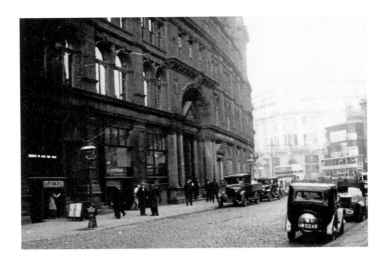

Hanging Ditch, 1930

The road takes its name from the ancient water course which ran beneath the road connecting the rivers Irk and Irwell. In 1600 the Hanging Ditch was condemned as an unsanitary open sewer, and in the following years the ditch was culverted and the bridge buried and built over. The medieval bridge can still be seen below the visitor's centre of the cathedral. The Printworks was developed from the original newspaper building, which, before it closed in 1986, was the largest newspaper printing house in Europe.

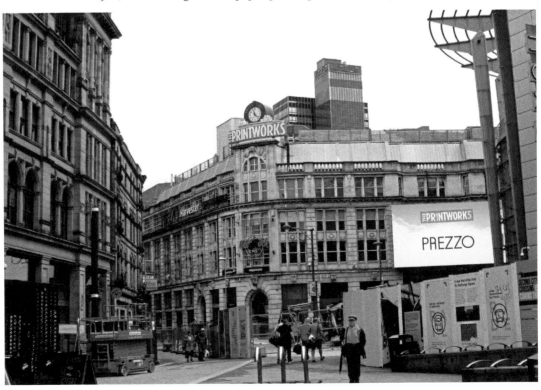

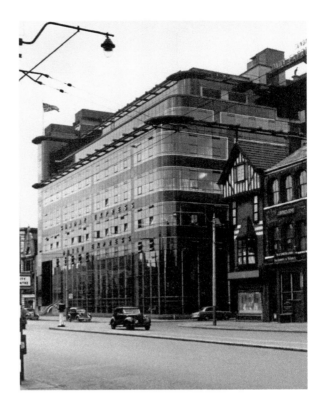

Daily Express Building, 1935
This iconic building is on Great Ancoats Street. The paper had been printed on the site since 1927. Built in 1939, the building is futurist art deco. It is clad in a combination of opaque and vitrolite glass. It was considered highly radical at the time and incorporated a growing technology, curtain walling. When Lord Beaverbrook commissioned the building, The *Daily Express* had a huge circulation. Sadly the paper left Manchester in the late 1980s.

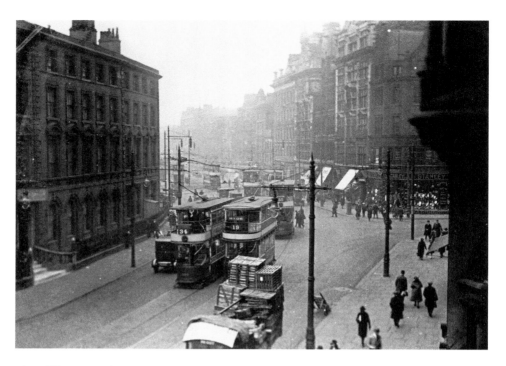

Piccadilly, Towards Newton Street, 1924

A very busy view of trams heading for Hyde. On the left we see the Queens Hotel, once the best hotel in town. This section of Piccadilly was always busy with travellers heading for London Road station. Now it is busy with pubs and bars reflecting Manchester's café society. The photo below shows an untypical hot summer's day in the city.

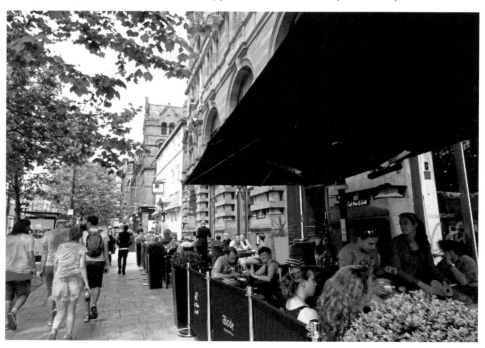

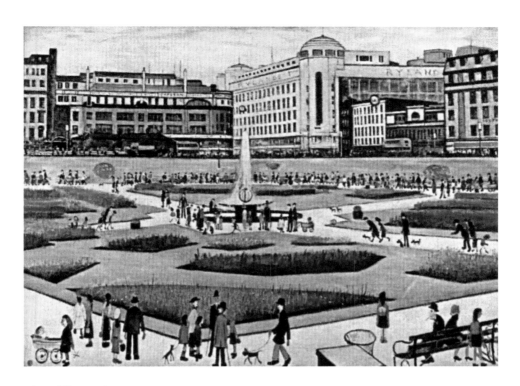

Piccadilly Gardens, Lowry, 1954

Manchester City Art Gallery commissioned this painting of Piccadilly Gardens in 1954. The director was not happy with the original sketches; however, it can now be seen in the gallery on Mosley Street. In 2011 there was a project to recreate present day visitors to the gardens as Lowry's 'matchstick men'. Sadly the formal flower beds and traditional fountain are gone forever.

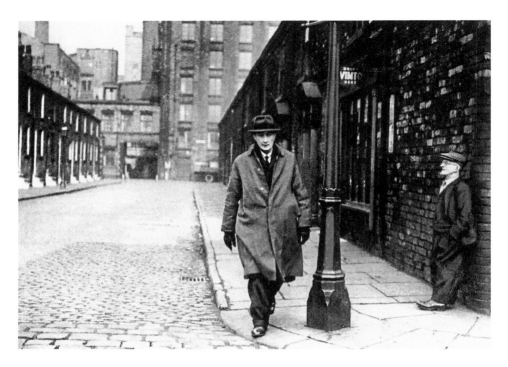

Lowry at New Cross

Lowry was a familiar site strolling through Manchester. Here he is in New Cross in 1968, an area he knew well, having walked the streets collecting rents for many years. Many of the mills along Great Ancoats Street are featured in his paintings. Today, the area is being regenerated and houses have been lovingly restored. Happily art is still featured with this sculpture of mill workers.

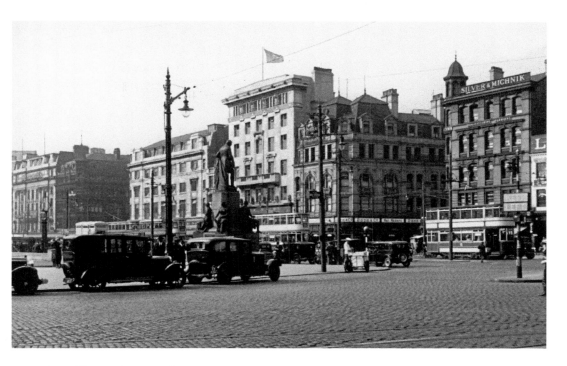

Piccadilly Gardens, 1936

Above is a view taken from Portland Street showing Wellington standing proud in the centre. Piccadilly was the site of the original Manchester Infirmary which was demolished in 1909. We can see Silver & Michnik, the Manchester furriers, and Dunn & Co., the hat-makers. The view from this corner is now dominated by trees so we turned the camera around to show the Piccadilly Plaza.

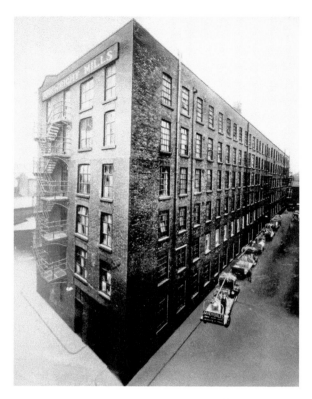

Miller Street, Arkwright Mills, 1930
In 1780, Richard Arkwright began construction of Manchester's first cotton mill in Miller Street next to Angel Meadow. This was the first example of a large purpose-built mechanised cotton-spinning mill in Manchester and it put Manchester at the forefront of the Industrial Revolution. The mill was eventually destroyed in a German bombing raid in 1940. This area became the centre of the Co-operative Wholesale Society. The CIS tower we see was designed as a prestige headquarters to showcase the co-operative movement in Manchester. When it was built in 1962 it towered over the city.

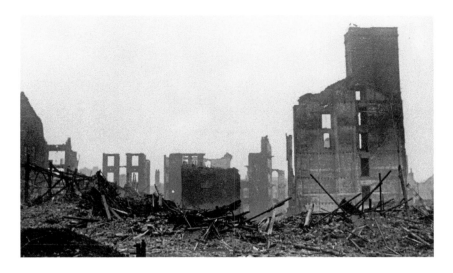

Miller Street Blitz, 1940

In the Christmas blitz in December 1940, an estimated 684 people died and 2,364 were injured in Manchester over two nights of bombing. On the night of December 22–23, a squadron of 270 aircraft dropped 272 tons of high-explosive and 1,032 incendiary bombs on the city. On 23–24 December, another 171 aircraft dropped 195 tons of high-explosive and 893 incendiary bombs. The map shows the devastation with red circles for fire bombs, blue circles for high explosives, and red shading for demolished buildings.

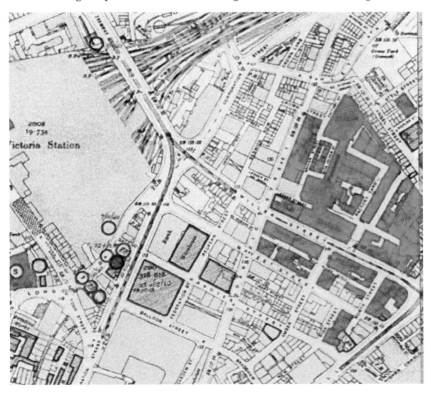

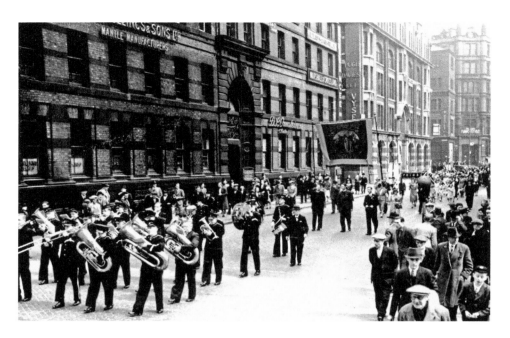

Whit Walks, 1940

As we can see, being at war was not going to stop the scholars. The Manchester Italian Catholic Society was formed in 1888 and organised the most popular event of the calendar of Little Italy, the spectacular 'Festa of the Madonna of Mount Carmel'. The Italian community of Ancoats always presented a fine spectacle with their huge statues covered in flowers, the tradition continues to this day. In the photograph below they are seen on Newton Street in 2015.

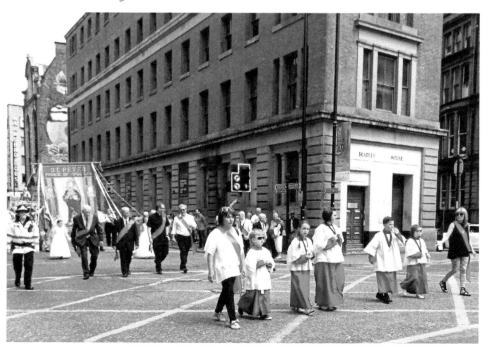

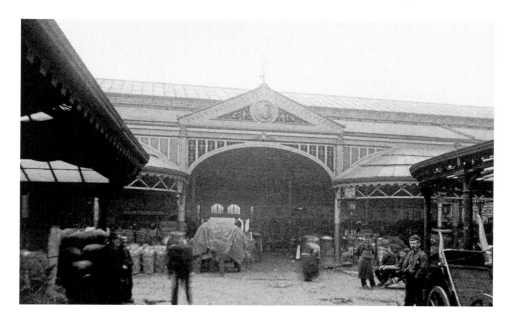

Shudehill Market

The first stalls started to appear on Shudehill about 1844. In 1853 the fine iron and glass roof was added. By the 1950s the market dominated the area including Swan Street. For those who rose early enough, the market provided one of the sights of Manchester as at about 6.00 a.m. each market day, the surrounding streets were congested with hundreds of horse-drawn 'lorries' and carts, heavy laden with vegetables, coming to market. The area was also famous for its second-hand book stalls. The market moved in 1973 and the area has now become the flourishing lively Northern Quarter.

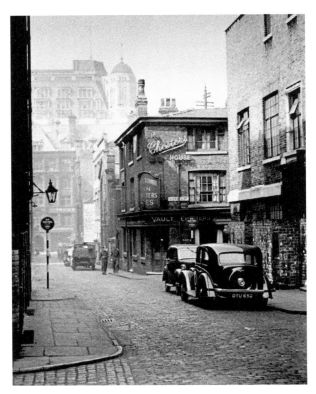

Bootle Street, 1946

The photograph above shows a view looking down towards Deansgate. The Sir Ralph Abercrombie can be seen on the right. Many pubs were named after heroes such as Abercrombie. He was born in 1734. He was a Scottish soldier and politician. He rose to the rank of lieutenant-general in the British Army and was noted for his services during the Napoleonic Wars. With the pub's location right next to Bootle Street police station, there was a certain infamy about the place and one of the few places you could guarantee a lock-in if the landlord liked you, particularly as the constabulary next door turned a blind eye due to many of them wanting to pop in at all hours after a shift ended.

Oxford Street from Central Library, 1948

A high shot taken from the library looking down Oxford Road. Bomb sites are still in evidence. The cenotaph stands proudly in the square. We can see the Odeon cinema on the left thought to be the oldest cinema in Manchester. The corner site on the right was the home of The Prince's Theatre, built in 1864 and remodelled in 1869. The final performance took place in April 1940. The theatre was demolished shortly afterwards, the intervention of the Second World War meant that the cinema was never built; the site is now occupied by Peter House.

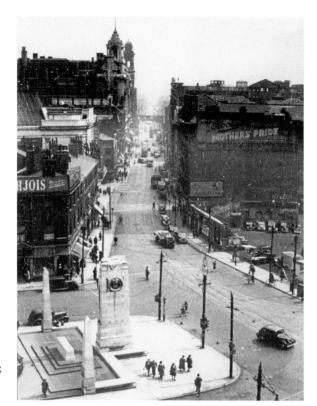

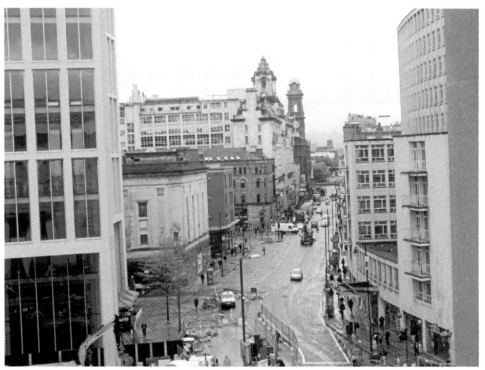

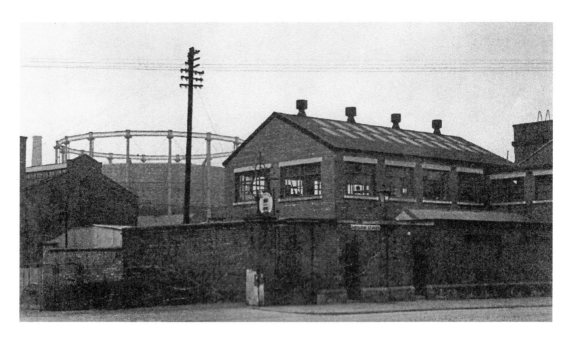

Gaythorn Gas Works, 1954

This site, beside the railway viaduct and adjacent to Medlock Street, was used for more than 100 years for the production of gas. In 1825 The Provincial Portable Gas Company of London constructed a works for the production of gas. Apparently, at some point there were some suggestions that the site might be home to the new BBC studios in the city but as we now know they went to the Salford Quays. Now a new £25 million arts centre – HOME – containing five cinemas, two theatres, a gallery, bar and café, has transformed the site bringing life to this rather dreary part of the city.

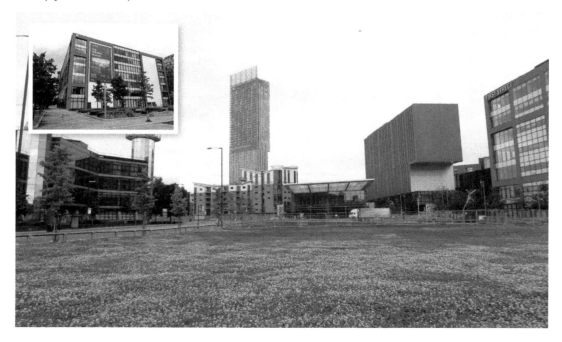

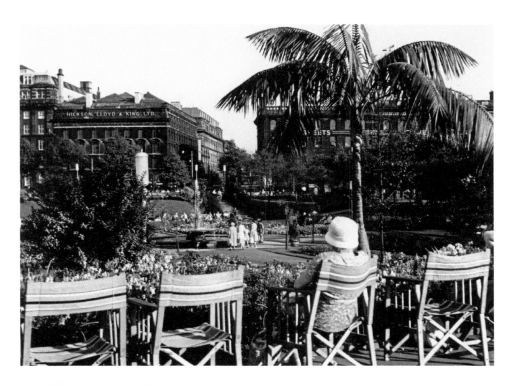

Piccadilly Gardens, 1961

I love this photo of Piccadilly Gardens. It is just how I remember the gardens as a child. Full of flowers and palm trees, with a traditional fountain in the centre. The woman could be on the French Riviera. The gardens were remodelled in 2002; some think rather brutally.

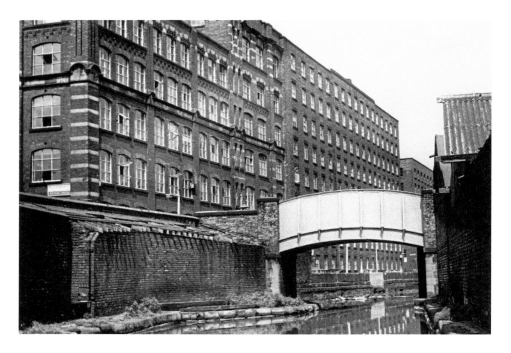

Royal Mill, Ancoats, 1962

The mill on the corner of Redhill Street was constructed in 1912 beside the Rochdale Canal. It was originally called New Old Mill and was renamed following a royal visit by George VI and Elizabeth in 1942. A plaque commemorates the occasion. It is a fine example of an historic industrial mill, built in red brick, terracotta, stone dressings and Baroque detail. It was a first generation mill, purpose-built for electricity. It has now been transformed into fine apartments.

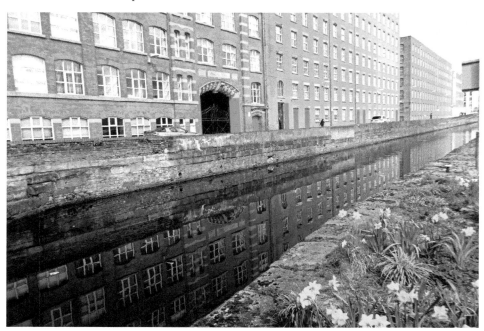

St Peter's, Ancoats, 1962

By the time St Peter's was built in 1859; Ancoats had been transformed from a small township into a bustling and overcrowded industrial place. It was the first Anglican church to be built in this predominantly Roman Catholic community. The declining congregations resulted in its closure in 1960. This landmark Romanesque church is now fully restored and acts as a symbol of Ancoats growing regeneration from its former dereliction. It is now a permanent rehearsal centre for the Hallé ensembles and a resource for the whole community.

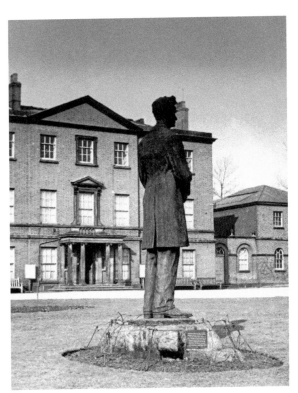

Lincoln Square

The replica of Barnard's bronze of Abraham Lincoln was intended for London but instead it was presented to the city of Manchester. The unveiling ceremony in Platt Fields in 1919 was an unashamed celebration of Manchester's liberal values. Manchester was a very important ally to Abraham Lincoln's Union during the American Civil War. Manchester took a strong moral and political stance by choosing to boycott southern cotton in protest against the use of slave labour. This led to the Lancashire cotton famine. Lincoln wrote a letter to thank the people of Manchester for their support. The statue was moved to its current position in Lincoln Square in 1986. It was mounted on a new pedestal on which was engraved extracts from Lincoln's letter.

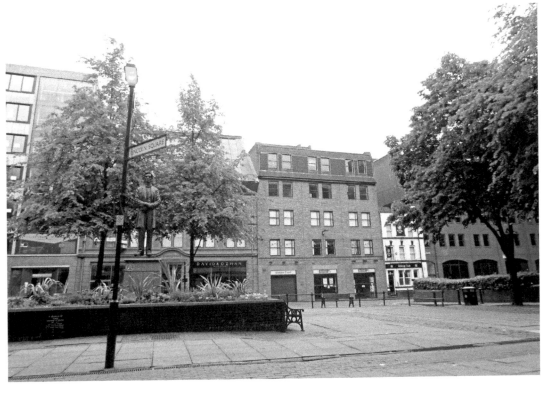

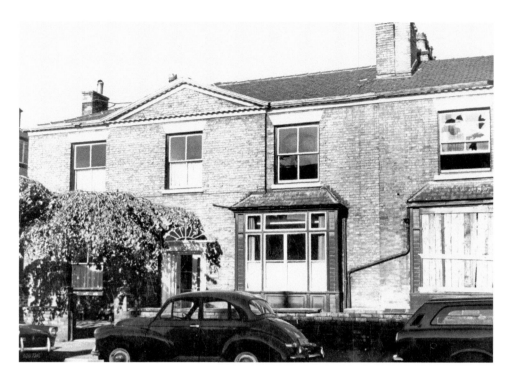

Pankhurst Centre, No. 62 Nelson Street

Manchester's radical history was the ideal place for the Suffragette movement to begin. The first public meeting was held, where else, but at the Free Trade Hall in 1868. This was the home of Emmeline Pankhurst and her daughters Sylvia, Christabel and Adela who led the campaign for votes for women. The centre was opened in 1987 by Barbara Castle and Helen Pankhurst. The villas now form a centre that is a women only space which creates a unique environment for women to learn together, work on projects and socialise.

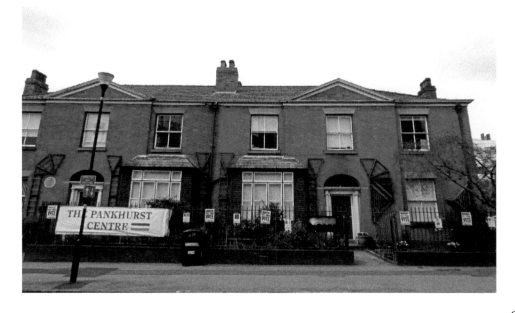

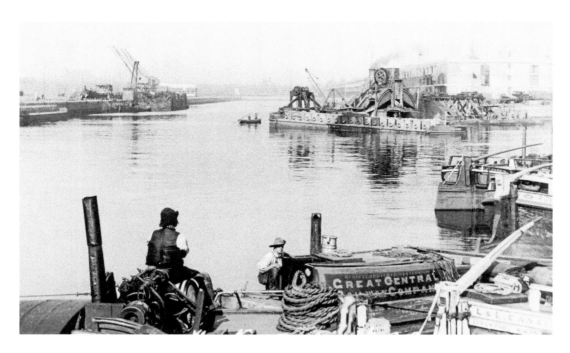

Manchester Ship Canal, New Docks, 1890
A very early view of the new docks at Salford. The site was bought from Lord Egerton. This photo is looking over towards Trafford Wharf. We see a barge of the Great Central Railway. The origins of the GCR may be traced back to the earliest days of railways in and around Manchester and its principle traffic was the movement of coal. This quay by the Lowry Theatre has been fully landscaped.

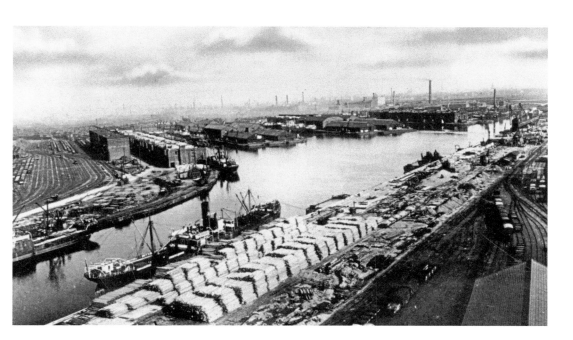

Manchester Ship Canal, 1936

A view of the docks on the Salford side taken from Trafford Wharf. Timber being a major import of the wharf. The timber was loaded straight onto the railway wagons. We can see No. 6, No. 7 and No. 8 dock across the water but the huge No. 9 dock is just off the picture to the left. No. 9 was the largest and last dock to be built. It was the site of The Manchester Liners service to Montreal. In 1936 when this photo was taken the docks were suffering the trade depression of the 1930s. It is now totally transformed and we see the Lowry Theatre and Media City.

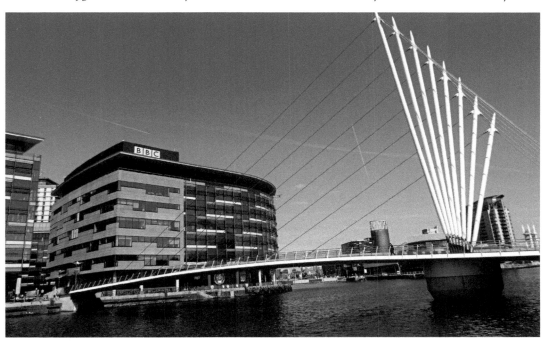

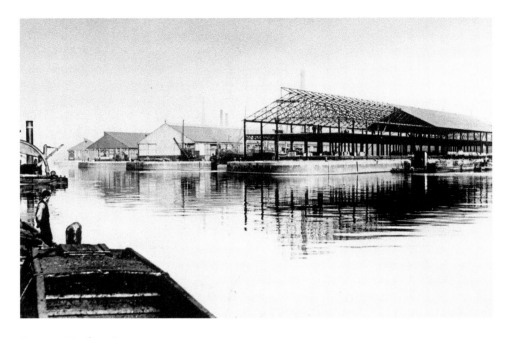

Pomona Docks, 1894

Pomona docks were built on the eastern side of the ship canal. The docks were built near the site of the former Pomona Gardens. Out of the eight docks here, only one dock at Pomona was actually in Manchester. A familiar site at Pomona were the Guinness shipments; the *Lady Grania* and the *Lady Gwendolen* were regular visitors delivering Guinness from Dublin. These ships ceased their Manchester deliveries when the main depot was moved to Runcorn in the early 1970s. Unlike the Salford Quays these docks have not been redeveloped.

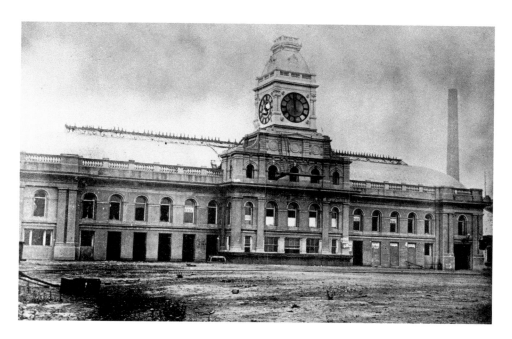

Pomona Palace, 1887

This was home to botanical gardens and to the music hall, the Royal Pomona Palace. It was opened in 1846 by the Beardsley brothers in an effort to rival Belle Vue. The public were brought along the river by steamship and by omnibus. It was known originally as the Cornbrook Strawberry Gardens; it was soon renamed after Pomona, the Roman goddess of fruit trees. The glory of the palace and gardens was relatively short-lived. In the 1880s a nearby chemicals factory exploded, damaging the hall considerably. Many apartment blocks have been built by the canal and there is talk of developing this area, near Cornbrook, much like Salford Quays.

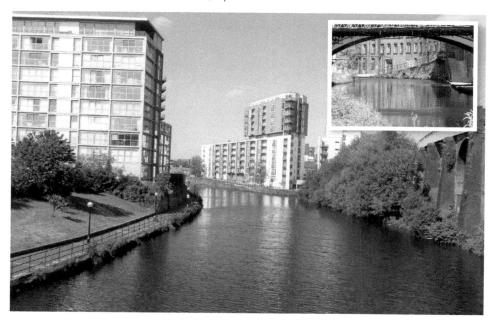

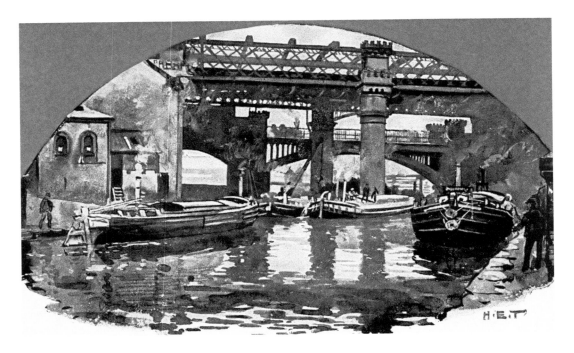

Castlefield Canal, 1900

The site of the Roman settlement. In 1765, the Bridgewater Canal was opened at Castlefield, creating a level link by water between the Duke of Bridgewater's coal mines at Worsley and the centre of Manchester. The area has been landscaped retaining the names of the great warehouses built around this basin. Many are still standing and have been converted for modern use.

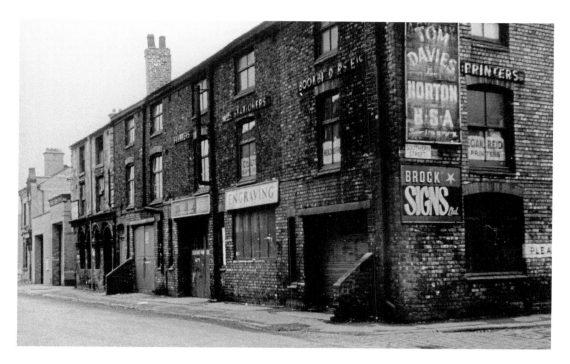

Southern Street, Castlefield, 1972

The photograph above shows a view of the area before the redevelopment. It was designated as a conservation area in 1980 and was the United Kingdom's first designated Urban Heritage Park in 1982. Numerous archaeological digs have taken place and revealed a great deal about the early history of the city. It's now a pleasant area to bring the children to learn the history of Castlefield.

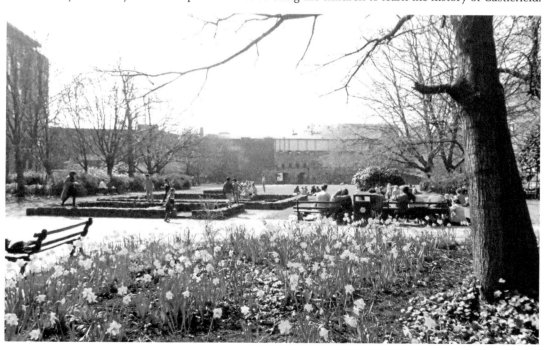

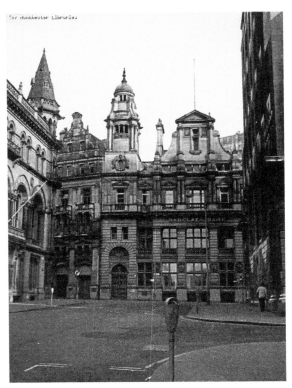

Spring Gardens, 1973
At the top of King Street we see the
Lancashire and Yorkshire Bank with
its tall turret. Built around 1888 it has a
huge and splendid banking hall which
can still be seen today as it is now an
Italian restaurant, Rosso's. On the right
the fine Midland Bank building is now
another Italian restaurant, Jamie Oliver.

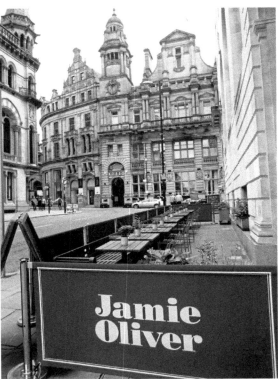

Acknowledgements

Thank you to Manchester Archives for permission to use photographs from their collections, www.images.manchester.gov.uk and their fine map and directory collection.

If you have not yet visited the new archives in Central library, then I urge you to visit. The exhibitions, film booths and digital interactivities bring Manchester's story to life.

Thanks to Graham Sumner for allowing us to reproduce his artist impression of Roman Manchester AD 79.

Also to Cross Street chapel for allowing us to reproduce their image of the chapel.

The painting *Piccadilly Gardens*, 1954, by Lowry is reproduced under licence DACS LR15-00945.

Finally, my brother Tom Goss for his advice and guidance.

Bibliography

Baines Lancashire Directory, 1825
Clare Hartwell, Mathew Hyde and Nikolaus Pevsner, *Manchester and South East Lancashire*: 1969
Linnaeus Banks, *The Manchester Man*: 1896
Oxford Literature Guide to The British Isles: 1978
Oxford Dictionary of National Biography Online

About the Authors

Jean managed the local history collection in Runcorn and Widnes library for many years. She has also created the image website for Halton – www.picturehalton.gov.uk

She has published a number of heritage walk leaflets for Halton Library Service and is currently producing an oral history of Halton. Recently retired, she is an adult tutor, offering courses in family history.

John has numerous production credits in theatre, TV and film. Ex-BBC and Granada. He has worked mainly for the last decade in portrait, film and artscape photography.

Previous publications – *Widnes Through Time, Cheetham Hill, Crumpsall, Blackley and Moston Through Time* and *Runcorn Through the Ages.*